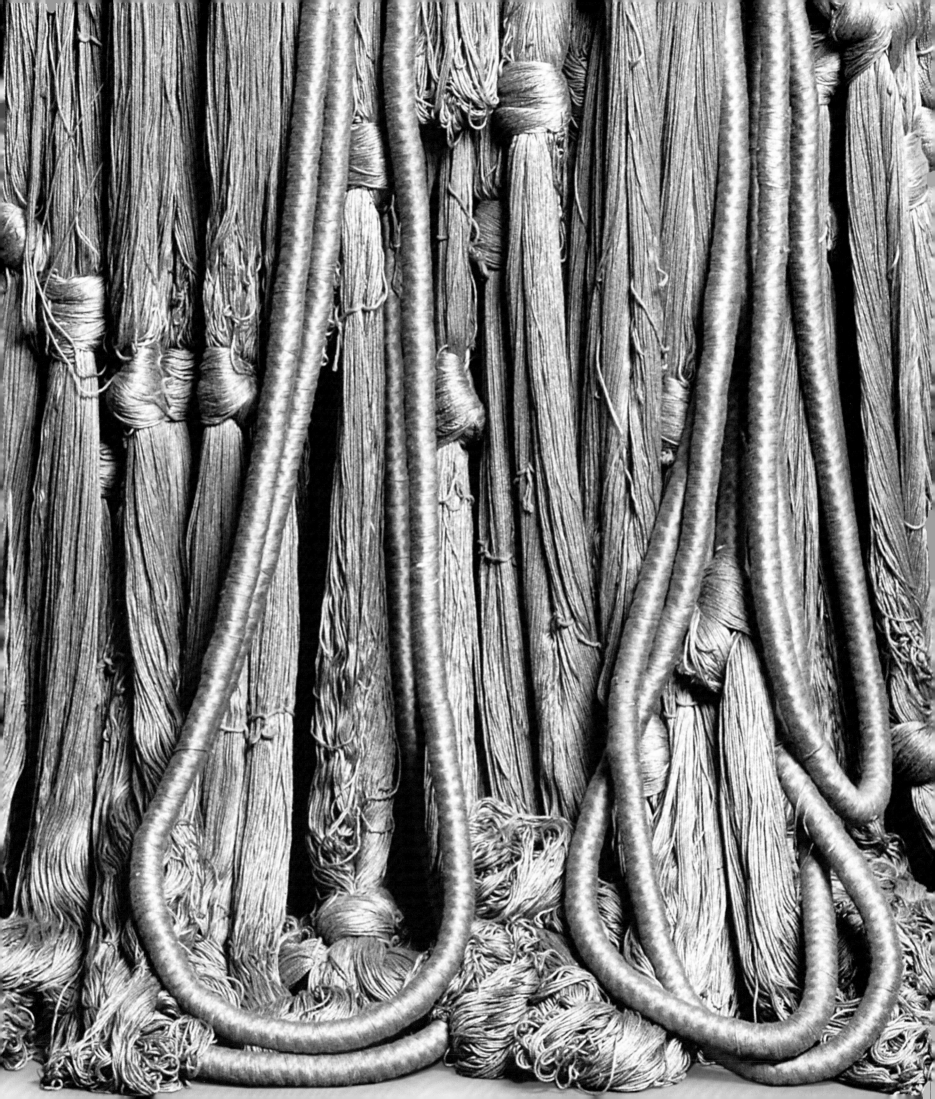

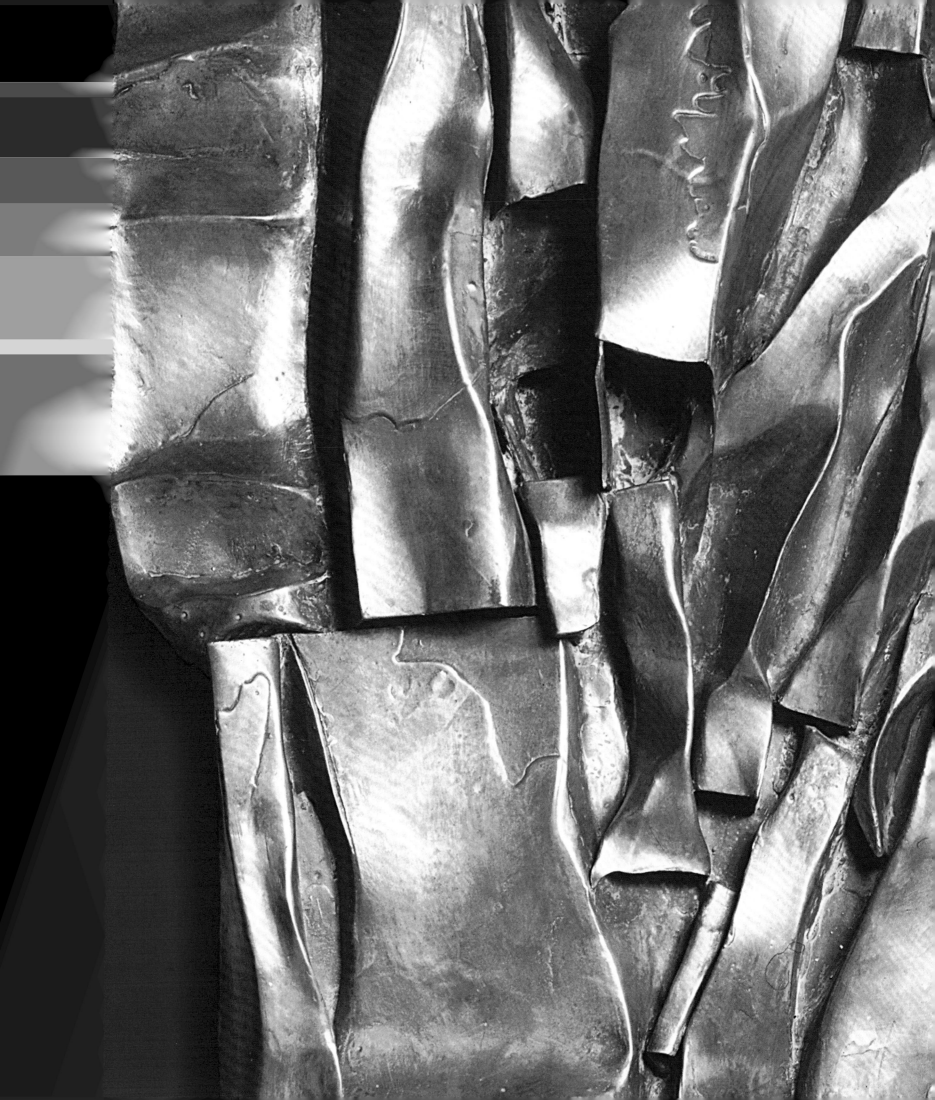

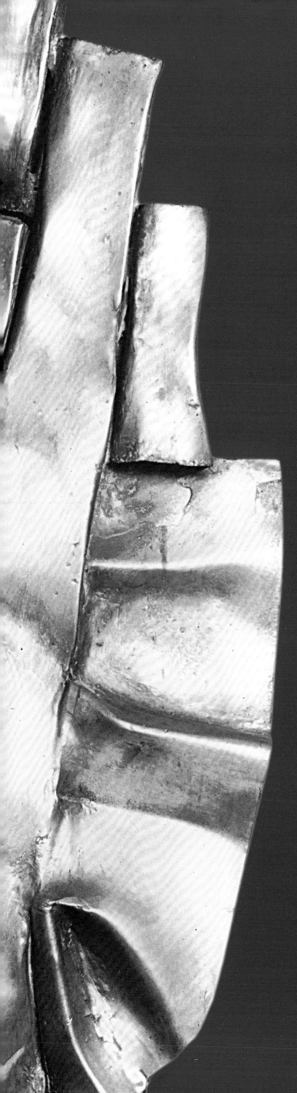

Barbara Chase-Riboud: The *Malcolm* X Steles

Edited by Carlos Basualdo

Texts by

Carlos Basualdo

Barbara Chase-Riboud

Gwendolyn DuBois Shaw

Ellen Handler Spitz

Chronology by John Vick

Philadelphia Museum of Art

Published on the occasion of the exhibition *Barbara Chase-Riboud: The* Malcolm X *Steles*

Philadelphia Museum of Art, September 14, 2013–January 20, 2014
University of California, Berkeley Art Museum and Pacific Film Archive, February 12–April 27, 2014

The exhibition was generously supported by The Andy Warhol Foundation for the Visual Arts.

The catalogue was made possible by The Andrew W. Mellon Fund for Scholarly Publications at the Philadelphia Museum of Art.

Produced by the Publishing Department
Philadelphia Museum of Art
Sherry Babbitt, The William T. Ranney Director
of Publishing
2525 Pennsylvania Avenue
Philadelphia, PA 19130-2440 USA
www.philamuseum.org

Edited by David Updike with Sarah Noreika
Production by Richard Bonk
Designed by Steven Schoenfelder
Printed and bound in Canada by Transcontinental Litho
Acme, Montreal

Cover: *Malcolm X #11* (detail of plate 9)
Pages 1–3: *Malcolm X #3* (details of plate 2)
Page 6: *The Foley Square Monument, New York* (detail of plate 27)

ISBN 978-0-87633-246-7 (PMA)
ISBN 978-0-300-19640-5 (Yale)

Library of Congress Control Number: 2013945408

Photography Credits
Amanda Jaffe: plates 5, 8, 9; p. 107, top left, bottom left; p. 108, bottom left
Mauro Magliani: plates 6, 7, 10–13, 18, 21, 22; p. 108, top left, top right, bottom center, bottom right
Jason Wierzbicki: plates 14, 23–42
Graydon Wood: plate 2

Contents

For Moira —
with great admiration BCR

Lenders to the Exhibition

Barbara Chase-Riboud

Roger and Caroline Ford

The Metropolitan Museum of Art, New York

Mott-Warsh Collection, Flint, Michigan

The Museum of Modern Art, New York

The Newark Museum, New Jersey

Noel Art Liaison, Inc.

University of California, Berkeley Art Museum

and Pacific Film Archive

Barbara Chase-Riboud Feb-12 2014

Foreword

This exhibition represents a homecoming of sorts. Barbara Chase-Riboud is a Philadelphian by birth. Her early encounters with the arts included classes at the Philadelphia Museum of Art and the Samuel S. Fleisher Art Memorial. A graduate of Philadelphia High School for Girls and Temple University's Tyler School of Art, Chase-Riboud received her initial training as an artist here before completing her education at the Yale University School of Design and Architecture.

Proud as we may be to claim Chase-Riboud as one of our own, we must also recognize her as a citizen of the world. She has lived and worked abroad, principally in Paris, since 1960—an experience that has marked her, not as an outsider and distant observer of all that has transpired here since she left this country more than a half-century ago, but rather as an artist with a perspective that is unique and perhaps more insightful for having done so.

Celebrated for her accomplishments as a novelist and poet, Chase-Riboud made her mark first as a sculptor, a medium in which she has continued to work throughout her long and illustrious career. This is the principal focus of the exhibition that this catalogue accompanies, and it is our great privilege to present an important and impressive body of work, the series of monumental sculptures that the artist has created in memory of Malcolm X, along with other sculptures and a selection of her remarkable drawings.

Among the many things that one might say about her drawings and sculpture, what I find most striking—and it is perhaps the strongest and most durable thread that binds all of Chase-Riboud's work—is the indelible presence of memory. Her impulse as an artist is to commemorate, and her dominant mood lyrical, or, better still, elegiac. This sentiment is most eloquently expressed in the beautiful series of steles that she has fashioned from bronze and textile over the past four decades. Abstract in both form and detail, they are none-theless endowed with a powerful anthropomorphic presence, one that reminds us of one of the most time-honored—and still durable in our own time—functions of the plastic arts.

We are fortunate to have one of the finest of these works, *Malcolm X #3* (1969), in our own collection, purchased in 2001 with funds generously donated by Regina and Ragan A. Henry, a former trustee, and delighted to have the opportunity to present this sculpture in the company of other steles and a handsome group of drawings by the artist. It has been a great pleasure as well as a privilege to work closely with Barbara Chase-Riboud on this project, and I would like to express our thanks, first and foremost, to her for her cooperation and generosity of spirit.

The staff of our Department of Modern and Contemporary Art, most notably Carlos Basualdo, the Keith L. and Katherine Sachs Curator of Contemporary Art, who organized this exhibition and edited and contributed an essay to the catalogue that accompanies it,

as well as John Vick, Project Curatorial Assistant, who provided Mr. Basualdo with research and administrative support and compiled a chronology of Chase-Riboud's career for the catalogue, also deserve our recognition and our gratitude. We are deeply indebted to several scholars, Gwendolyn DuBois Shaw, Associate Professor of American Art at the University of Pennsylvania, and Ellen Handler Spitz, Honors College Professor of Visual Arts at the University of Maryland, Baltimore County, as well as Barbara Chase-Riboud herself, for the essays that they contributed.

Within the Museum, many departments have helped with the development of both exhibition and catalogue. Among these I will single out only two for mention, as unfair as that may be: Our Department of Installation Design, led by Jack Schlechter, created the elegant installation design for the exhibition, while the staff of our Publishing Department, guided by Sherry Babbitt, the William T. Ranney Director of Publishing, was responsible for the editing and production of this catalogue. They and the many other staff members who have helped us fulfill the goals of this project in ways both large and small deserve our recognition and deepest thanks.

For parting with their treasured works of art for the duration of this exhibition, we are grateful to our lenders: Roger and Caroline Ford; The Metropolitan Museum of Art, New York; the Mott-Warsh Collection, Flint, Michigan; The Museum of Modern Art, New York; the Newark Museum, New Jersey; Noel Art Liaison, Inc.; and the University of California, Berkeley Art Museum and Pacific Film Archive.

Finally, I am grateful to have this opportunity to express my thanks to the staff and trustees of The Andy Warhol Foundation for the Visual Arts for their generous financial support of the exhibition, and to say how delighted we are that the exhibition will be presented next year at the University of California, Berkeley Art Museum and Pacific Film Archive, thus ensuring that it will be seen by a larger appreciative audience.

Timothy Rub
The George D. Widener Director and Chief Executive Officer

Vertical Dreams

The *Malcolm X* Steles

Carlos Basualdo

1. *LE LIT*

The couple lies in a liminal space between consciousness and sleep. There are no sheets or blankets on their naked bed, which itself is a blank surface, anxious like a page that bears witness to the writer's silence. Silence itself takes the shape of the rectangular bed, and surrounds it in shadows. The bed, a bare surface drawn in perspective, is seen from above, and the harsh light of the drawing seems to come from that direction, coinciding with our gaze. The couple casts shadows that are deep and narrow, closely circumscribing the bareness of their bodies. They lie on the bed in opposite directions, across from each other, with their gazes turned in the direction of the other's body. They are noticeably male and female, but their sex is hidden in a mesh of undulating lines. Seen from above, the female is upright and the male upside down, as if falling. The hips of one figure seem to be fused with the other's shoulders. The shape of their upper bodies forms a powerful square at the center of the composition, providing the drawing with a center of gravity. Male and female come together at the very point where the clarity of the line becomes blurred and entangled so that the drawing approaches dissolution.

Toward the heart of the night, the sleeping body ascends and descends into the changing landscape of the imagination. The physical world becomes less tangible, dampened with dreams. The verge of the real world seems close, yet truth and fiction are still entangled. Sleepers are swimmers restlessly moving toward a tangible shore of light. The couple in one of the first drawings from Barbara Chase-Riboud's *Le Lit (The Bed)* series, from 1966, appears to have reached the shore already, and now the hardened surface of their bed is pushing them apart (fig. 1). There seems to be no other option available to them but to assume another form, to return to their dream by allowing the lines that made their tentative shapes to take

them away from their own bodies, in the direction of the landscape that they thought they had abandoned.

In 1966, *Le Lit* enacts an existential drama, and thus immerses itself in a certain lineage of the art produced in Europe in the postwar period. The first drawing of the series finds echoes in the works of artists such as Alberto Giacometti (fig. 2), Germaine Richier, and Francis Bacon, sharing not only a set of formal resemblances, but also a similar treatment of the human figure, which is portrayed as a dubious icon of its own fragility. But rather than continuing to explore the pathos of the figure by anchoring it progressively into its singularity and vulnerability—as in the work of these other artists—Chase-Riboud chooses to allow the line in her drawings to explore other horizons, apparently less tainted by the pathos of a terminal form of humanism. In the next set of drawings from the series, the bodies have dissolved into a linear configuration that coalesces around the shape of a landscape with rocks and gorges (see plates 12, 13). Finally, shining surfaces and lines become a glorious iris of rumpled sheets from the lost bed, endowed with the gloss of metallic waves, shimmering on top of the most deep and darkened background (see plate 14). Perhaps in order to escape the representation of the body, which, in the art of the postwar period, stands as the physical manifestation of sexual isolation and tragic deceitfulness, Chase-Riboud forces the line in her drawings to mimic—and to trace—the avatars of a natural force: geological accidents or multiple streams of water splashing on a rock. The final *Le Lit* drawings firmly explore the realm of the mutable, with the human figures transformed in an unstable landscape of mineral dreams.

As the line takes the figures in the *Le Lit* drawings further away from the depiction of bodies and toward the realms of the mineral and the mutable, the inherent tension of the works is displaced from a narrative connected to the figures themselves to the formal relation

Fig. 1. Barbara Chase-Riboud, *Le Lit (The Bed)*
(detail of plate 11)

opacity of a more solid and definitive background. If we still assume, and there are no reasons not to, that the viewer is ideally situated on top of the works, looking down, the activity would still take place mostly at a horizontal level, as in the first drawings. The oneiric mineral landscapes of *Le Lit* are thus depicted both frontally and from above, so that their mutating shapes correspond to an ambiguous sense of orientation. *Untitled*, 1966 (see plate 15), concludes that progression, which so far had clearly assumed a narrative structure, by depicting a form that stands at the intersection of the organic and the mineral, the vertical and the horizontal, fluid like water and yet paradoxically hardened like tempered metal, shining with a lunar pallor against the solid dark background.

The evident sculptural quality of the *Le Lit* drawings would be made explicit in the extraordinary series of three-dimensional works that Chase-Riboud realized in 1969 and chose to title *Malcolm X*, in homage to the civil rights leader (see plates 1, 2 and Checklist, p. 106). The passage from the drawings to the sculptures seems to have been the product of an intense period of experimentation, and its consequences would have a lasting effect on the artist's subsequent works. Throughout the early *Malcolm* sculptures runs a sense of both curious hesitation and serendipitous trepidation that culminates in the resounding monumentality of

between figure and ground. In the first drawings, the flat, unspoiled surface of the rectangular bed served as a ground for the recumbent bodies, with the dark background acting as a framing device. As the series progresses, the bed takes on more of the quality of a surface onto which the changing constellation of folded sheets or rocks is initially configured. Subsequently, the bed becomes a window through which the rock formation projects a depth that seems to reach the groundlessness of the surrounding darkness. Finally, the bed disappears and the hardened formation stands lit against the consistent

Malcolm X #3 (see plate 2), where the itinerary traversed by the drawings and early sculptures reaches an undeniable sense of completion.

Chase-Riboud had experimented with casting techniques since the mid-1960s, and the first *Malcolm* is the product of the artist's exploration of a specific technique that involves modeling thin sheets of folded wax, which are then used for the casting process.[1] It is possible that the imagery in the final drawings of the *Le Lit* series was inspired by the quality and appearance of the sheets of wax used in the casting process, so that the technical experimentation may have found its formal counterpart in the drawings from 1966. Undoubtedly, the sculptures emerge from an obvious desire to produce tangible forms that would echo the transformations taking place in the drawings. If the final drawings of the *Le Lit* series progressively suggested a vertical orientation for the figures—which becomes much less ambiguous in later drawings—the first *Malcolm* seems to return to the horizontal plane, where the folds of metal expand both laterally and upwardly. That ascending movement could also be read in the opposite direction, as flowing sheets of liquefied metal fusing with a horizontal surface that, once again, brings to mind the rectangular bed in the *Le Lit* series. Because a low pedestal supports the sculpture, the viewer has to look down on it—as was the case with the first drawings—an orientation that accentuates the horizontal quality of the work. Two questions seem to have emerged for the artist at this point: First, how to make it possible for the transitional figure or landscape represented in the work to emerge from the horizontal plane in order to assume more fully its identity as a self-standing entity; and second, how to maintain the strong connection to the background

Fig. 2. Alberto Giacometti (Swiss, 1901–1966). *Automatic Drawing*, 1943. Graphite on paper, 12¹³⁄₁₆ × 9⅝ inches (32.5 × 24.5 cm). Private collection

that remains a central element in the drawings. It seems as if the question at this point would have been how to contain the mutability of the represented forms so that their ambiguous identity could paradoxically become more clearly defined, or, to express it in different terms, how to delimit and circumscribe the constellation of references of a formal system based on ambiguity and transformation that may have been generated out of the desire to escape the aesthetics of postwar existentialism. Evidently, the formal problems are, fundamentally, questions of meaning for Chase-Riboud, as the narrative sequence in the *Let Lit* drawings made clear. In their anxious appeal to gravity, formlessness, and horizontality, Chase-Riboud's drawings and sculptures of this period find, interestingly, a

conceptual resonance in the contemporary work of artists such as Lee Lozano and Eva Hesse.

The transition enacted by the metamorphic episodes of *Le Lit* is that of a line that escapes the depiction of the body—or bodies—and moves toward a mutating field with no clear coordinates, where the fluid and supple coexist with the solidity and permanence of the mineral world. It can also be seen as the tentative impulse to abandon a system of aesthetic references to postwar humanism that by the mid-1960s had been powerfully codified in the work of artists such as Bacon, Giacometti, and Jean Dubuffet: the condition of the isolated individual subjected to threatening forces that transcend, determine, and ultimately annihilate her. Chase-Riboud uses her terse and restless line to progress in the direction of a more rarefied field of references in which the organic and the mineral, the artificial and the natural, exist as interchangeable. She does this by using the line in her drawings to create surfaces that fold and unfold, assuming a changing set of qualities, while manipulating surfaces of wax in a complex casting technique that ultimately allows her to treat bronze as a malleable liquid surface. The results are sculptures that paradoxically enact a frozen moment of passage, while still pulsating with the restlessness of that transformative impulse. At the time of her first *Malcolm*, this activity was taking place at a horizontal level, as ripples in a surface, still too close, one could guess, to their possible dissolution. For the works to retain their fluid identity and their fundamentally paradoxical character—that of suggesting a constant process of transformation while remaining still—they had to become more clearly differentiated from their backgrounds, and thus, to become erect.

2. MALCOLM X

The solution at which the artist arrived consisted, first, in literally displacing the horizontal orientation of *Malcolm X #1* by raising the surface of the bronze so that it became vertical. A metonymical process, that displacement had the effect of forcefully isolating the sculpture, emancipating it from the possible contamination with the background that was implicated in the horizontal plane. Now the form could be perceived as such, in its singularity—face-to-face, in a manner of speaking, and not looked down upon, as with the first *Malcolm*. The erect form—which would itself progressively take on the meditative character of a pillar, the very cipher of erection—would gradually mutate to assume a more logical relation with gravity, and this accounts for the elongation of the bronze element that is clearly perceptible in the transition from *Malcolm X #2* to *#3*. That elongation is reinforced by the vertical disposition of the bronze coves, creeks, and folds in the passage from one work to the other. Yet the bronze element nonetheless retains traces of its horizontal quality—and thus a vestige of its conceptual origins and methodology of fabrication—which the vertical orientation of the sculptures would never fully cancel. Although all subsequent *Malcolms* with the notable exception of *#4* would be vertical, they do not perform that verticality seamlessly, as a sign that has changed its position in the signifying chain but does not quite adjust to its new meaning. More than being abstract, the works retain traces of their figurative quality, as constellations of unstable signifiers. Their identity, although well defined, remains fundamentally in question.

Having changed the orientation of the bronze plate, the question of how to structurally

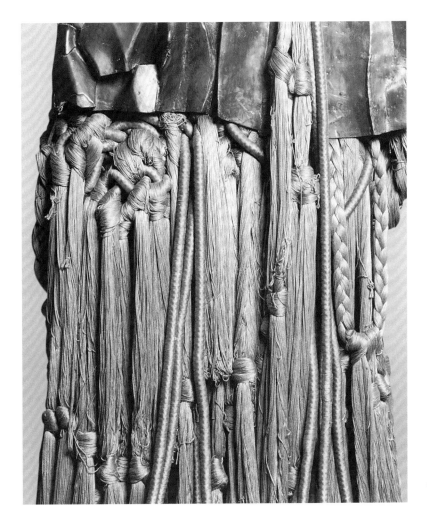

Fig. 3. Barbara
Chase-Riboud,
Malcolm X #3
(detail of plate 2)

support the folded metallic surface would become key. The artist's first, somewhat tentative, solution—to use a supporting armature hidden in the back of the bronze surface—proved sufficiently unsatisfactory for Chase-Riboud to feel compelled to revisit it several years later. The most recent *Malcolms* are conceived as self-supporting bodies and thus have become progressively independent from the wall (see plates 6, 9, 10 and Checklist, pp. 107–8). The remaining question for the artist was how to connect the vertical surface of the cascading bronze folds to the floor. As Peter Selz notes, the astonishing solution came from Chase-Riboud's collaboration with her friend and fellow artist Sheila Hicks, and was possibly also inspired by

her trips to China in 1965, Senegal in 1966, and Algeria in 1969.[2] Chase-Riboud attached to the bronze body a "skirt" of cords, tresses, and knots of silk and wool, which had the effect of both anchoring the sculpture and making the mass of bronze levitate. In the work of Hicks, the textile is used in true modern fashion so that its material qualities are evident and unmistakable. Chase-Riboud, profoundly faithful to her poetics of displacement and metamorphosis, would use the silk and wool so that it metaphorically alludes to ropes, to hair, to the festoons of a decorated uniform, to a toga, to streams of falling water (fig. 3).[3] Silk and wool do not enter into contradiction with the bronze; they mutually reinforce each other in their metonymic

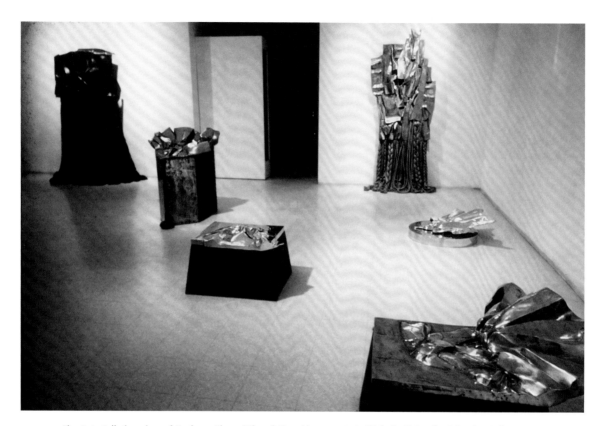

Fig. 4. Installation view of *Barbara Chase-Riboud: Four Monuments to Malcolm X*, Bertha Schaefer Gallery, New York, February 7–26, 1970. Shown (from left): *Malcolm X #2, Malcolm X #4, The Ultimate Ground, Malcolm X #3, The Ultimate Sound, Malcolm X #1*. Courtesy of the artist

qualities, so that they look and feel as intimately related as different parts of the same landscape. The transition from the horizontal to the vertical is almost didactically demonstrated by the first installation of the *Malcolm* sculptures in an exhibition at the Bertha Schaefer Gallery in New York in February 1970 (fig. 4). There one can see the first *Malcolm* in the foreground, aligned in an ascending diagonal with other works from the series, including *Malcolm X #4* and *#2*. In an opposite corner, against the wall, *Malcolm X #3* stands isolated, the conclusive result of the process of reorientation of the sculptures. Closing the circle, *The Ultimate Sound,* a smaller, earlier aluminum work with a folded surface similar to that of the first *Malcolm,* lies on the floor as

a pond at the feet of the severe and monumental *Malcolm X #3*.

The towering, increasingly erect *Malcolms* would thus take the unstable, metamorphic quality of the *Le Lit* drawings back to the signifying realm of the anthropomorphic. Firmly planted on an ascending stream of golden or black—and later red—silk and wool, with their backs to the wall, their presence becomes that of a standing figure, while their undulating, at times stressed, bronze surfaces appear to acquire the quality of armor. Armor seems to have been very much in Chase-Riboud's mind at this time, as demonstrated by drawings she made in 1966 in connection with a commission from Pierre Cardin to create two

Fig. 5. Barbara Chase-Riboud, *Drawing for Pierre Cardin Sculptures, Paris*, c. 1966. Charcoal and charcoal pencil on paper, 30 × 22³⁄₈ inches (76.2 × 56.8 cm). Courtesy of the artist

sculptures—which she described as "abstract suits of armor"—for the celebrated fashion designer's building on the Champs-Élysées (fig. 5). A final transmutation thus takes place when the works become inflected by the imposing and threatening quality of the armor. The constellation of possible meanings that the works invoke becomes precisely defined, existing between the anthropomorphic and the purely transformational, the horizontal and the vertical, forms of a becoming that traverses the mineral and the organic realms, alluding both to human forms and to natural phenomena.

As indicated, the first four *Malcolm* sculptures had their debut at the Bertha Schaefer Gallery in New York in the winter of 1970. In the small catalogue of the exhibition, the sculptures are described as "monuments," which calls attention to the artist's intention when choosing a title for the works.[4] Their monumental quality corresponds closely to their title, and both seem to stem from the impulse to partially solidify and consolidate what initially appeared to be a fluctuating field of references implicit in the formal idiom of the sculptures. It is worth noting that, after the 1970 New York show, the textile

component of *Malcolm X #3* was extended to emphasize the verticality and monumental quality of the work. The ultimate effect, once again, was that of reinforcing the tension between opposites on which these works are predicated, and from which they obtain both their aesthetic success and their disturbing quality. The naming of the *Malcolms*, and the artist's insistence on the nonrepresentational quality of the series, call attention to the problematic relation that exists between modern art and memorials. Even if the viewer is expected not to confront the sculptures as portraits, and clearly that is not the way in which the artist conceived them, the formal qualities of the works may find resonance—and meaning—when considering the historical figure of *Malcolm X*. Faithful to their poetics of transformation, the works are such that they allow those possible associations to take place, while avoiding the potential meanings to be permanently settled. Most recently, Chase-Riboud has referred to these works as "steles," a name that, at least at the formal level, is especially appropriate for *Malcolm X #10* to *#13*, all realized in 2007–8, while this exhibition was already being planned. It is perhaps the nonrepresentational nature of the steles that attracted Chase-Riboud to this term, as she is keen on emphasizing that the viewer should not read into the sculptures attributes of the historical figure to whom she dedicated the series. But equally apt is the fact that ancient steles were most commonly inscribed, and thus used to commemorate with language a significant event or the death of a notable person—the Rosetta Stone, for example, is a stele. Like ancient steles, the *Malcolm* sculptures are products of a process of inscription. They are conceived as an arrangement of floating signifiers, signs in the process of losing

their attachment to a specific set of references. Steles are, indeed, veritable seals that both cancel a certain lived experience while opening a more social and literary field of remembrance—gateways that articulate a passage between the personal and the historical, the dimension of subjective perception and that of common language. They publicize a past event or deceased hero in the social dimension, while inevitably silencing the private dimension of that event or person, thus underscoring the fragility of the subjective experience of time. The *Malcolm* sculptures, with their luscious and sensual surfaces, so reminiscent of the fluidity of the natural world, also conceal an ascetic core of silence. They are carefully constructed signs of the possibility of change and transmutation, now frozen. In their eminent vitality, they stand as iconic testimonies of death, anxiety, and disappearance.

This exhibition was initially conceived to include a selection of the *Malcolm* sculptures, of which the Philadelphia Museum of Art possesses an outstanding early example, *Malcolm X #3*, from 1969. While considering the works from this series, the need to include a group of the artist's extraordinary drawings became evident. As much as Chase-Riboud considers the development of her drawings independent from the sculptures, it is possible to trace a progression from the works on paper to the bronzes. Most importantly, careful observation of her drawings allows the viewer to reconstruct the constellation of cultural and formal references that seems to have informed the artist's imagination when she conceived the first *Malcolm* sculptures. Progressively distancing herself from the intellectual horizon of postwar existentialism, she produced an iconic series of sculptures dedicated to the redemptive

possibilities of a syncretic approach to cultural contexts and materials, deeply anchored in her faith in the modern aesthetic language. Because the formal aspects of Chase-Riboud's works are indissociable from their conceptual implications, it became clear that in order to trace the progressive development of the *Malcolms*, the exhibition should also contain other, typologically related examples of her bronze sculptures. Among other works, two of her *Tantra* sculptures (see plates 5, 7) and *All That Rises Must Converge / Red* (see plate 8) are included in order to examine the artist's practice consistently. Lastly, it became clear that her exceptional *Monument Drawings* from 1996–97 (see plates 23–42)—which seem to return to and expand both the qualities of her earlier drawings and the intentions that initially animated her *Malcolm* sculptures—had to be part of the exhibition as well.

At the very heart of Chase-Riboud's project is a modern question: How do we memorialize with a language that interrogates itself as much as it does that which it describes? Or, to put it differently: How do we speak in tongues while pronouncing that which must be remembered? Malcolm X is certainly one of the most powerful and poignant historical figures of our times. Chase-Riboud's ascetic icons, in their contained excess, are persuasive reminders of the possibilities, and sorrows, of our modern aspirations.

basically the fruit of our collaboration in that it is only black wool, and only one knot. There are no cords, no other workings of the wool, no silk yet, or variations in the wool, and really it is quite simple and primitive. If you then go to *Confessions for Myself* [see plate 3], you will see how it evolved into the baroqueness of hangings, loops, elaborate cords, marine cords, mixed qualities of other wools and fibers, and even wrapped granite pebbles attached to the skirt, and other inventions I conceived of as we went off on our own separate ways."

4. *Barbara Chase-Riboud: Four Monuments to Malcolm X*, exh. cat. (New York: Bertha Schaefer Gallery, 1970).

NOTES

1. See the Chronology by John Vick in this volume.
2. Peter Selz and Anthony F. Janson, *Barbara Chase-Riboud: Sculptor* (New York: Harry N. Abrams, 1999), p. 31. See also the Chronology in this volume.
3. As the artist described in conversation with the author: "If you go back to the skirt of *Malcolm #2*, you will find

Malcolm X Rising

Barbara Chase-Riboud's Phenomenological Art

Gwendolyn DuBois Shaw

Malcolm X #3 (1969; see plate 2) rises sharply against the gallery wall, a crumpled and folded mass of poured bronze atop a cascade of undulating twisted and knotted silken cords dyed the same golden hue as the metal structure from which they issue. Towering nearly ten feet, it dominates the viewer's field of vision, a silent sentry commanding one's attention. This formidable sculpture is one in a series of thirteen "skirt sculptures" by Barbara Chase-Riboud dedicated to the American civil rights leader who was assassinated in 1965.[1]

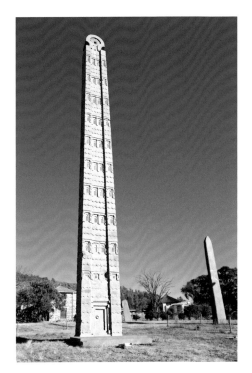

Fig. 2. King Ezana's Stele, Axum, Ethiopia, fourth century. Height 67 feet (20.6 meters). Photograph © iStockphoto.com / Guenter Guni

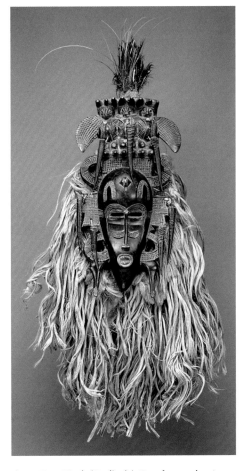

Fig. 1. *Face Mask (Kpeliye'e)*, Senufo peoples, Ivory Coast, nineteenth to mid-twentieth century. Wood, horns, raffia fiber, cotton cloth, feather, metal, sacrificial material; 30½ × 13 × 9 inches (77.5 × 33 × 22.9 cm). The Metropolitan Museum of Art, New York. The Michael C. Rockefeller Memorial Collection, Purchase, Nelson A. Rockefeller Gift, 1965 (1978.412.489). Photograph © The Metropolitan Museum of Art / Licensed by Art Resource, NY

According to the artist, the bifurcated structure of these sculptures, which allows for the sudden transfer of "the characteristics of one material to another," evolved because she "wanted freedom from the tyranny of the base and legs," finding the answer in traditional dancing masks, such as those created in communities in Burkina Faso, Sierra Leone, and Ivory Coast (fig. 1), in which the porters are concealed by fibers.[2] Although the work's formal connection to ancient steles (traditionally a carved or inscribed upright stone or pillar used to commemorate an important event or person; fig. 2) and its suggestion of human-initiated movement inspired by African masking traditions are relatively easy to see, its potential to memorialize a specific individual, Malcolm X, is far less simple to describe.

How might the abstract form of *Malcolm X #3* serve as a monument to such an iconic historical figure, one whose likeness has been ingrained in popular memory through the mass reproduc-

tion and distribution of powerful photographic imagery? How does it evoke the man whose name it is given without drawing on this legacy of representation? These questions have vexed many critics and art historians who have attempted to interpret the *Malcolm X* series, as well as Chase-Riboud's visual art in general. Her resistance to the formula that scholars often rely upon to discuss the work of superficially similar artists, as I outline below, has emphasized her exceptional place among modern abstract sculptors of the last half century.

Unlike her contemporaries, such as the Italian Arte Povera artists, who found an important champion in critic and curator Germano Celant, or the American Minimalists, who gained legitimacy in large part through their perceived opposition to the formal mandates of Clement Greenberg and Michael Fried, Chase-Riboud has rarely been examined in the context of larger artistic movements in America, a situation shared by other singular artists of the same generation, including Lee Bontecou, whose ovoid reliefs have remained understudied to this day. Instead, critics and art historians have preferred to discuss the trajectory of her career, her interest in ancient Chinese, Greek, Roman, and African art forms, or her prodigious literary production and reputation that includes best-selling novels and acclaimed books of poetry. My aim is to consider why the long line of objects produced within her artistic practice have been so challenging for scholars. What I believe is missing from the literature on Chase-Riboud is some good close looking that considers her work on its own terms and engages with the objects on the merits of their thingness and their phenomenological impact on the viewers who stand before them.

There are two ways of seeing: with the body and with the soul. The body's sight can sometimes forget, but the soul remembers forever.

—Alexandre Dumas, *The Count of Monte Cristo*

Shortly after marrying the celebrated French Magnum photographer Marc Riboud in 1961, Chase-Riboud started to expand the repertoire of traditional sculptural materials, including clay, plaster, and bronze, with which she had been trained to work as an undergraduate at Temple University's Tyler School of Art in Philadelphia and as a graduate student at Yale School of Design and Architecture. During the mid-1960s, she sometimes incorporated bones and other found objects into her work. By 1965 she had begun using wax sheets, which she cut, stacked, and folded, melting and manipulating their surfaces with a torch. She shuttled between her home in Paris and Verona, where she worked with the Bonvicini foundry to have them cast as experimental plaster sculptures. She adopted the special wax used by Bonvicini in its casting process, which did not crack or melt excessively when the torch was applied, yet flowed easily from the mold when the final cast was being made. By the end of the decade, this wax formula and the surfaces that Chase-Riboud was able to create with it had become part of the artist's trademark style and working method. She had also begun to incorporate fiber into her sculptures, a move that prompted her to experiment with fixed viewpoints. "The last few sculptures have been in relief," she explained in 1971. "I think it is because I am combining these sculptures with another material, which is silk or wool. It seems to lend itself to a sort of flat relief sur-

face rather than a three-dimensional one." She found significance in "taking a hard material and a soft material and making them work together."[3]

Chase-Riboud had asked her Yale classmate and good friend Sheila Hicks, who lived and worked in Paris during the mid-1960s, how she could hide the "legs" of her increasingly abstract sculpture without having to deal with the "tyranny" of the base. Hicks's suggestion was to hide the armature with skirt-like wool. Beginning with black wool and a special knot that Hicks showed her how to make, she began the fabrication of the skirts that became the secondary abstract element in the sculptures. This process was used in *Malcolm X #2* (1969; see plate 1), the first in the series to incorporate fiber and the first one to be done in black bronze. In combining fibers with the bronze, Chase-Riboud could then expand upon the possibilities of what she now calls the *Malcolm* steles.

The orientation of *Malcolm X #3*, one of the four original steles first exhibited in 1970 at the Bertha Schaefer Gallery in New York, as well as the *Malcolm* sculptures that followed, controls how viewers experience the work by limiting their movements. Pressed against the gallery wall, with only a few of its silken cords resting on the plinth below, the sculpture appears to hover in midair in a space all its own. All but the front remains a mystery; viewers cannot walk behind it. One wonders how the back of the work might look. Does it resemble its façade, a highly polished surface of folds and crimps? That the sculpture must be approached from the front, as though it were a monarch on a throne, creates a sense of formal rigidity and control that moves viewers to respond with awe and submission.

To engage with the phenomenological experience of the work, one must take time to study the bronze crevasses and cords that give it the power of its thingness. The upper half of *Malcolm X #3* is a staunched flow of once-liquid metal transformed into a shiny surface of crevasses and apertures, of spaces and places for secretion. Each planar junction produces a new network of spaces where the viewer's eyes can rest and mind can wander. At various points between the crevasses, the planar surface is broken by thin lines that hint at superficial layers having been chipped or peeled away. In these spaces the bronze appears as if it were cast from sedimentary rock, with bits and pieces sheared from the surface to reveal the fragile layers beneath. On each side of the upper portion a horizontally folded piece of bronze cascades downward, its borders edging up to frame the vertical mass of crimped and folded metal. Here and there a small knob of bronze breaks the surface, causing the eye to pause momentarily.

While the physical boundaries delimit the viewing orientation of *Malcolm X #3*, the confluence of bronze and fiber that bisects the larger form highlights the differences between the sculpture's soft and hard surfaces. A few fibers extend higher than their peers, entering the bronze form about a foot above the rest. The pliable and smoothly textured threads, collected and coiled into complementary groups of braids, bundles, or cords that rise and fall together—at one moment resembling a cascading braid of hair, at another a measure of rope that might bind a person's wrists or a chain that might tether a captive prisoner—create a network of veins and nerves that bridge the space between the upper portion and the plinth, pushing the work just outside of the viewer's space. Each skein of thread makes a new relationship with space and surface, the clusters passing through

complexes of knotted junctures before disappearing into the bronze and then reemerging, cascading toward the plinth again and again and again, as though caught in an infinite loop, ends vanishing into the superstructure like snakes entering burrows or intravenous lines making subcutaneous entries. The dense layering of the fibers, knotted every few feet in some places and every few inches in others, produces a sense of infinitude and depth that appears to recede to the wall against which the sculpture rests.

The soft cords spilling forth from the hard bronze upper portion suggest the innards of an animal hung for slaughter, its tangled and knotted intestines sliding from its slit belly onto the abattoir floor, a mass of vital organs made useless. What once provided life through the extraction of nourishment for the body has been laid to waste, exposed to the consumptive gaze. Yet, beyond hinting at a kind of animistic death, the corded fibers that spill from beneath the bronze reference the creation of the piece by echoing the wax channels, or sprues, through which the molten bronze flowed to make up the core of the sculpture. Now lost to sight by the finishing process, these channels—vestigial tentacles of bronze reaching out into space—would have been connected to the surface of the piece immediately after its casting and then removed by a professional bronze worker. The discarded sprue finds its ghost in the skeins of silken thread that jostle for space in the stele's lower half, forming a heavy skirt that hides the sculpture's support structure and inner workings.

The upper portion of the sculpture reveals concretized evidence of the artist's manipulation of her medium. What began in the studio as a smooth sheet of wax—a tabula rasa, a planar expanse of pliable material—was folded, melted, and merged, forever altered and manipulated. In the final bronze cast, a densely expressive surface on which are recorded the myriad aesthetic choices of the artist, the lost-wax process reveals itself. In the uppermost register a horizontal splash pattern, a reminder of the liquid potential of the original wax model, breaks the vertical movement of the now-fixed bronze folds, giving the material a sense of fluidity that works against our perception of it as static. Ghosted upon the surface of the bronze, the dribble and flow of wax made liquid by Chase-Riboud's torch endure, the surface of the paraffin once molded by her fingers standing as the indexical marker of her actions. In this way the artist has made it seem as though the metal was crumpled and folded in upon itself, gathering energy into its center before being fixed forever in time and space.

Glowing in places with the golden tones of polished bronze, darkly textured in others with the patina of time, *Malcolm X #3* is profoundly compelling—an upright, vaguely anthropomorphic form that seems to wear a protective cuirass and fiber skirt, recalling the armor of ancient Greek or Roman warriors. Its surface speaks of choices made and forms manipulated, and yet it continues to change over time as patina creeps across its surface, corrupting the golden bronze with a greenish-gray tinge, making shiny parts a little dull and rough spots a bit rougher. The delicate green film has accreted in the creases of the bronze, adding color and character to the form, helping us recognize the material's slow, organic life cycle and its ability to morph and to endure, exemplified by ancient Greek statuary that survived for millennia beneath the volatile waves of the Mediterranean, as in the case of the Artemision Bronze (c. 460 BCE; fig. 3), blackened with

Fig. 3. Artemision Bronze, c. 460 BCE. Bronze, height 82¼ inches (209.9 cm). National Archaeological Museum, Athens. Licensed by Vanni / Art Resource, NY

age and brittle to the touch yet still whole and recognizable as Zeus or Poseidon. Such temporal detritus reminds us that the only way to destroy a bronze sculpture completely is by the same mode used in its creation: by melting it down. It is this process, visible on the surface of Chase-Riboud's piece in the pentimenti of the wax sheets that formed the work's original model, that pushes the element of mortality to the fore by juxtaposing the fragility of human existence, exemplified by the individual life of Malcolm X, with the enduring nature of human civilization (i.e., history), in this case exemplified by the continued discovery of ancient Greek sculptures.

By 1972, the black skirt of *Malcolm X #2* had become the towering immobile black mass of the Berkeley Art Museum's *Confessions for Myself* (see plate 3), a wall of thirteen different shades of black wool and textures and as many different cords and knots, some of which wrapped black granite stones. *Confessions* was followed by *Zanzibar/Gold*, which was acquired by the National Collections of France in 1976 and installed in the Ministry of Culture.

In 1979 the novel *Sally Hemings* was published worldwide, re-inventing Chase-Riboud as a best-selling author, a creative identity that has often publicly overshadowed her work as a visual artist. Other highly lauded novels and

poetry collections followed, and the artist did not return to the *Malcolm X* series for fifteen years, exhibiting other sculptures such as the *Tantra* and *Cleopatra* series. The *Malcolm X* steles reappeared in the 2000s along with the *Tantra* series, in which tripartite groupings of bundled and knotted silk fibers enhance the apparent levitation of each sculpture (see plates 5, 7). According to the artist, the intervening works in the *Malcolm X* series, such as *Malcolm X #13*, have become more "literate," more conversational, and despite the diversity and associational content of the material, she sees the work as being fundamentally formalist—working to achieve harmony, balance, and beauty through pure space and form.

The artist has insisted that her drawing and her sculptural practices are discrete and fulfill different desires: "I don't do preliminary drawings for my sculpture. They are drawings for the sake of drawing. I draw very quietly, very meticulously. It may take me three or four or five days to do a drawing. But with the sculpture I am much more impatient. I want to see it right away. I want to

see at least the basic form very quickly."[4] Nevertheless, the upper portions of the *Malcolm X* sculptures, cast from folded and scumbled wax originals, resemble the rumpled bedsheets of the artist's series of drawings from 1966 called *Le Lit (The Bed)* (see plates 11–14). This series reveals a transformation of form in two-dimensional space, as two human figures lying side by side in a rectangular field—arranged like yin and yang, with heads against one another's thighs—evanesce into a mass of overlapping cubist planes. It is as if these figures have been swallowed up in the space of the bed, their human identities transformed into pliable materials that can be folded and reconfigured, like the specially formulated Veronese wax that Chase-Riboud had begun using for her sculpture.

The *Monument Drawings*, which have been given distinctly literary and historical names, comprise large-format tributes to fictional characters, historical figures, and writers within renderings of stones and wrapped cords. These works both stand in individual tribute to the subjects whose names they bear, such as the nineteenth-century Russian poet Alexander Pushkin and the Count of Monte Cristo, the character created by the French writer Alexandre Dumas (see plates 29, 30), and present distinctive phenomenological forms that might be created in their honor. Pushkin, often hailed as his homeland's greatest poet and beloved for his drama *Boris Godunov* (1825–31) and his verse novel *Eugene Onegin* (1825–37), is the father of modern Russian literature. Dumas's hugely popular adventure novels, including *The Count of Monte Cristo* and *The Three Musketeers*, both published in 1844, have made him the most widely read French author of all time. Both men were what literary critics and theorists would call initiators of discur-

sive practices in the Foucauldian sense: Pushkin, who ushered in the romantic literary form in nineteenth-century Russia, and Dumas, who formulated the genre of adventure writing that led to the birth of pulp fiction and the pocket novel in the middle of the twentieth century, engendered new modes of popular public discourse through the creation and dissemination of their innovations.

As with the *Le Lit* drawings, in creating the *Monument Drawings* Chase-Riboud returned again and again to the sheet of paper as the image slowly emerged. Yet beyond their naming, the basic visual content of these drawings remains the same—delicate cross-hatching and fine gestural line covering the white page. An element of rope or cord, sometimes hovering, sometimes buried, is incorporated into the body of the drawing, creating forms that echo the organic viscera of the cords in the *Malcolm X* series. The stones in each drawing both resist and propose interpretation as they are constantly changed by the lines and cording that surround them. These stones become the leitmotif of the work, functioning like the cornerstone of the Kaaba, the ancient stone building toward which Muslims pray, which transfixes the believer and creates a space of deep emotional, spiritual, and phenomenological experience.

Chase-Riboud's ongoing engagement (and, I would say, identification) with transnational creative expression, exemplified by the cosmopolitans Pushkin and Dumas—both of whom were famous not only for their writings but also for their mixed African and European heritages—coupled with her interest in the possibilities for shared aesthetic experiences between artists and viewers, authors and readers, may explain many of her choices of individuals to cite in these

notable drawings. By giving two-dimensional form to what I would argue is an intensely personal experience—communing intellectually and aesthetically with artistic creation—Chase-Riboud engages the viewer in a uniquely transcendent, transglobal, and transhistorical discursive field where monumentalization is an ongoing aesthetic process.

One day, may we all meet together in the light of understanding.

—Malcolm X, *The Autobiography of Malcolm X*

Although many contemporary critics celebrated Chase-Riboud's abstract commemorative art, and the *Malcolm X* series in particular, they generally did not discuss in depth the phenomenological power of the works. While debate about the political categories of and aesthetic possibilities for African Americans who make art simmered in the early 1970s, the phenomenological potential of nonobjective forms to function as meaningful memorials did not become a topic of public discourse in the United States for another decade. The beginning of this discourse, however, can be traced to 1952 and the design of Isamu Noguchi's never-realized masterpiece *Monument to the Dead of Hiroshima*, intended for Peace Park in Hiroshima. Some critics argued that the sculpture was too abstract and therefore potentially incomprehensible to ordinary people. It was also rejected because Noguchi was an American citizen (though his father was of Japanese descent, his mother of European descent, and he had spent much of his childhood living in Japan), and it seemed inappropriate for Japanese survivors of the American atomic attack to stand in reverence before a monument made by a citizen

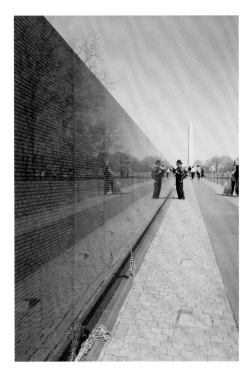

Fig. 4. Maya Lin (American, born 1959). *Vietnam Veterans Memorial*, Washington, DC, 1982. View from the apex, looking toward the Washington Monument. Photograph courtesy Library of Congress Prints and Photographs Division, Washington, DC

of the country that had dropped the bomb that destroyed the city and took more than one hundred thousand lives in the process.[5]

Three decades later, a very similar argument was sparked by the controversy surrounding the Vietnam Veterans Memorial designed by Maya Lin for the National Mall in Washington, DC (fig. 4). In 1981 Lin, an undergraduate architecture student at Yale, was awarded the commission for the design of a memorial to American service members who died or were classified as missing in action during the conflict. Lin's path-breaking minimalist design built on the recent history of abstract memorials by artists such as

Fig. 5. Robert Motherwell (American, 1915–1991). *Elegy to the Spanish Republic No. 1*, 1948. Ink on paper, 10¾ × 8½ inches (27.3 × 21.8 cm). The Museum of Modern Art, New York. Digital Image © The Museum of Modern Art / Licensed by SCALA / Art Resource, NY

Robert Motherwell, whose epic series *Elegy to the Spanish Republic* (fig. 5), begun in 1948 and continued over most of his career, comprises more than a hundred works—many of them large canvases of amorphous shapes, painted mostly black and white—lamenting the tragedies of the Spanish Civil War.

Despite such celebrated precedents, her plan—consisting of two walls of polished black stone engraved with the names of the fallen and the missing, set below ground level and meeting at a 125-degree angle—caused an instant uproar. Critics scoffed at the possibility that a nonfigurative form could convey adequately the emotional experience of the Vietnam War to veterans and the families of those who perished or whose

status was unknown. One dismayed veteran who testified in protest of Lin's plan before the United States Fine Arts Commission in October 1981 went so far as to suggest that the abstract design was a kind of aesthetic revenge perpetrated by the less-than-American artist (an Ohio-born woman of Chinese descent) who sought to deny real Americans (those of European descent) the marble monument they expected. Condemning the design as "a black gash of shame and sorrow," he implored, "Why can't we have something white and traditional and above ground?"[6] Ultimately, not only did Lin's vision win over the panel of architects, critics, and sculptors appointed to choose the memorial's design, but it convinced many dissenters when, after its dedication in 1982, they were able to experience its phenomenological power for themselves. Visitors standing before the reflective black surface traced the names of lost loved ones with their fingers and often burst into tears. The memorial's contemplative and cathartic potential quickly made it the most visited site on the National Mall.

While the memorializing potential of Chase-Riboud's *Malcolm X* sculptures had been unintelligible to some critics in 1970, by the early 1980s the Vietnam Veterans Memorial had begun to encourage even skeptical Americans to consider how abstract forms could commemorate individuals or historical events. Like Lin's monument, the *Malcolm X* series requires viewers to submit to the experience and to embrace the act of contemplating form, texture, and presence only. Through our submission to this phenomenological opportunity, we can experience the act of viewing as a significant form of commemoration.

Chase-Riboud's phenomenological, transcendent practice—which is simultaneously openly

narcissistic, with its focus on communicating her personal aesthetic experience, and hugely selfless by way of its efforts to memorialize the creative power of others—presents a significant challenge to critics.

**Sunset in the ethereal waves:
I cannot tell if the day is ending, or
the world, or if the secret of secrets
is inside me again.**

—Anna Akhmatova, "A Land Not Mine"

Chase-Riboud's bronze sculpture *Africa Rising* (fig. 6), commissioned in 1995 by the U.S. General Services Administration (GSA) in a competition that included several hundred sculptors, was installed in the lobby of the Ted Weiss Federal Building as a part of the commemorative program for the eighteenth-century African burial ground that lies partially beneath its foundations. Located in lower Manhattan, the burial ground, which had long been lost to history, was discovered in 1991 when construction crews working at the GSA building site unearthed the skeletal remains of the first of more than four hundred people who had been laid to rest beginning in the early seventeenth century, when the location was just beyond the borders of the Dutch West India Company's settlement of New Amsterdam. Through a partnership between the GSA and Howard University in Washington, DC, archaeologists began to excavate the site, in the process exhuming not only human remains, but also pieces of coffins and grave goods with which the deceased had been interred. The scientific analysis of materials found at the site yielded numerous and unexpected insights into the lives of the people buried there, creating a previously unre-

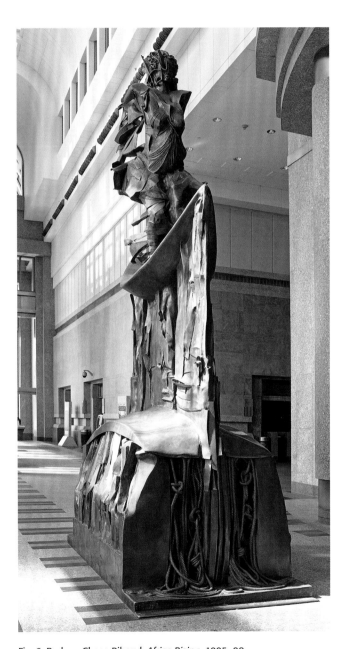

Fig. 6. Barbara Chase-Riboud, *Africa Rising*, 1995–98. Bronze, 185 × 102 × 52 inches (470 × 259 × 132 cm). Ted Weiss Federal Building, New York. Commissioned through the Art in Architecture Program, U.S. General Services Administration. Carol M. Highsmith Photography. Courtesy of the U.S. General Services Administration, Public Buildings Service, Fine Arts Collection

corded picture of African New Amsterdam and early Anglo New York. Unfortunately, in 2001 this research was disrupted irrevocably when nearly sixteen hundred boxes of artifacts from the site that were being housed in one of the World Trade Center towers were destroyed in the September 11 terrorist attacks. With the permanent loss of this material, the burial ground's memorial program at the GSA building site has taken on an added level of importance.

Chase-Riboud's *Africa Rising*, to date her most visually impressive and ambitious sculpture, dominates the lobby of the federal building and exemplifies the artist's formal journey from the 1970s to the end of the twentieth century.[7] This soaring, complex form features a winged female figure standing at the center of an arc supported by three vertical planes, the shape of which suggests an ancient Egyptian headrest. The arc in turn is held up by a rectangular base embedded with masses of coiled bronze that resemble the artist's signature fibers. *Africa Rising* is meant to be viewed in the round, its enormity commanding the space of its installation to a degree that Chase-Riboud's *Malcolm X* sculptures, meant to be seen from one perspective, cannot do.

In an essay on the relationship between Chase-Riboud's *Africa Rising* and her novel *Hottentot Venus* (2003), Carlos A. Miranda and Suzette A. Spencer argue at length for the importance of this sculpture in the context of the artist's oeuvre.[8] The sculpture responds to the experience of a particular Khoi woman, Sarah Baartman, known as the Hottentot Venus, who was abducted from her home in the Eastern Cape and enslaved by Dutch farmers before being convinced to travel to Europe, where, beginning in 1810, she was exhibited as a side-show freak. After her death in 1815, French scientists performed an autopsy on her body, preserving her skeleton, genitalia, and brain, which were displayed in the Museé de l'Homme in Paris until 1974. In 1994 Nelson Mandela called for the repatriation of her body to her homeland, a request that was not granted for nearly a decade. In August 2002 Baartman's remains were interred in the Gamtoos Valley in South Africa, near where she is believed to have been born more than two hundred years earlier.

In the 1970s, before they were removed from view, Chase-Riboud saw Baartman's skeleton and wax effigy in a glass cage at the Musée de l'Homme. In 1994, she decided to reinterpret Baartman as a Nike (or victory) figure on top of *Africa Rising*, a choice that she says was inspired by the Nike of Samothrace (c.190 BCE; see p. 88, fig. 9 below) and the Futurist sculptor Umberto Boccioni's *Unique Forms of Continuity in Space* (1913; see p. 88, fig. 10 below). In 2001, when the French finally agreed to return Baartman's remains to South Africa, the artist chose to write the historical novel *Hottentot Venus*.

In their article on *Africa Rising*, Miranda and Spencer argue that the mix of abstract and representational components in *Africa Rising* contends with "the sheer impossibility of making such monumental histories of suffering intelligible much less legible."[9] This tension between that which has been seen but is now lost to sight and that which cannot be visualized is the challenge that Chase-Riboud's work presents. I would argue, however, that Chase-Riboud's work as a creator of aesthetic experience is not so much about black history, or women's history, or black women's history, as it is about her personal engagement with being a living, breathing part of

this history and having a responsibility to elucidate its hidden, wronged, or neglected parts. This is perhaps why the *Malcolm X* sculptures, the *Monument Drawings*, and *Africa Rising* provoke such profound phenomenological experiences in viewers. These works operate beyond simple binaries, in a space of dualities and multiplicities, of potential and opportunity. To know this place, viewers must be prepared to submit to the experience and give it their full attention.

The transcendent aesthetic experience embraced by the viewer open to Chase-Riboud's work forms the commemoration of the fallen hero, the homage to the discursive initiator, the honoring of the unknowable suffering of ancestors. This profound act of submission and communion initiates a transfer of cathartic energy that enshrines and memorializes. The marks on paper, the elegantly knotted silk ropes, the gleaming bronze—these artistic mediums provide vehicles through which experiences might pass from the artist to the viewer. It is the viewer's phenomenological experience of Chase-Riboud's work that is central to its existence. Without the visceral reaction produced by the viewer's presence in the space of her work, without the viewer's receptiveness to examining the form, there is nothing. No story. No emotion. No easy takeaway with which to placate the busy art critic. The art of Barbara Chase-Riboud is not *about* something; it *is* something.

NOTES

1. Chase-Riboud, quoted in "On Her Own Terms: An Interview with Barbara Chase-Riboud," by Suzette A. Spencer, *Callaloo*, vol. 32, no. 3 (Summer 2009), p. 747.

2. Ibid., pp. 747–48.

3. This and the following quotation by Barbara Chase-Riboud are from *Five*, produced by Milton Meltzer and Alvin Yudkoff (Silvermine Films, 1971).

4. Ibid.

5. Bert Winther, "The Rejection of Isamu Noguchi's Hiroshima Cenotaph: A Japanese American Artist in Occupied Japan," *Art Journal*, vol. 53, no. 4, *Sculpture in Postwar Europe and America, 1945–59* (Winter 1994), pp. 23–27. http://www.jstor.org/stable/777557.

6. Tom Carhart, "Insulting Vietnam Vets," *New York Times*, October 24, 1981. ProQuest (121689759).

7. According to the plans, Chase-Riboud's *Middle Passage Monument*, a yet-unrealized memorial commemorating those who died on the perilous sea voyage between Africa and the New World, would be far more ambitious in scale than *Africa Rising*. See Peter Selz and Anthony F. Janson, *Barbara Chase-Riboud: Sculptor* (New York: Harry N. Abrams, 1999), pp. 128–30.

8. Carlos A. Miranda and Suzette A. Spencer, "Omnipresent Negation: *Hottentot Venus* and *Africa Rising*," *Callaloo*, vol. 32, no. 3 (Summer 2009), p. 923. doi:10.1353/cal.0.0486.

9. Ibid.

sculpture

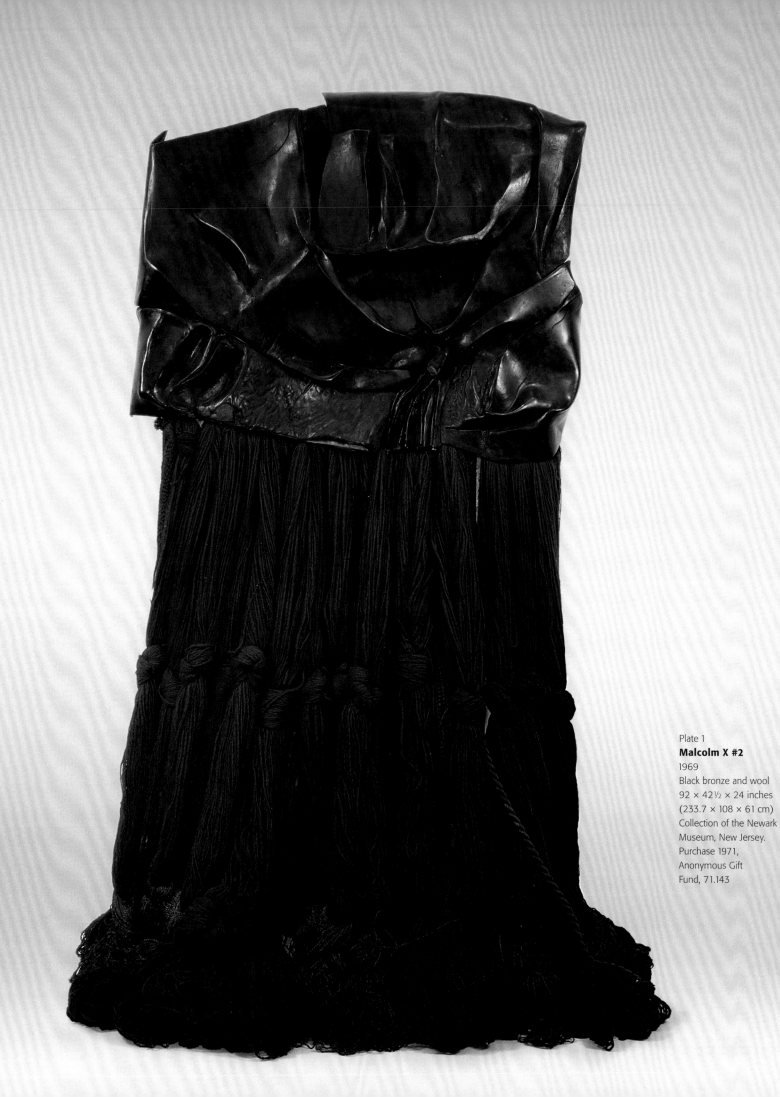

Plate 1
Malcolm X #2
1969
Black bronze and wool
92 × 42½ × 24 inches
(233.7 × 108 × 61 cm)
Collection of the Newark
Museum, New Jersey.
Purchase 1971,
Anonymous Gift
Fund, 71.143

Plate 2
Malcolm X #3
1969
Polished bronze, rayon,
and cotton
118 × 47¼ × 9⅞ inches
(299.7 × 120 × 25.1 cm)
Philadelphia Museum of
Art. Purchased with funds
contributed by Regina
and Ragan A. Henry, and
with funds raised in honor
of the 125th Anniversary
of the Museum and in
celebration of African
American art, 2001-92-1

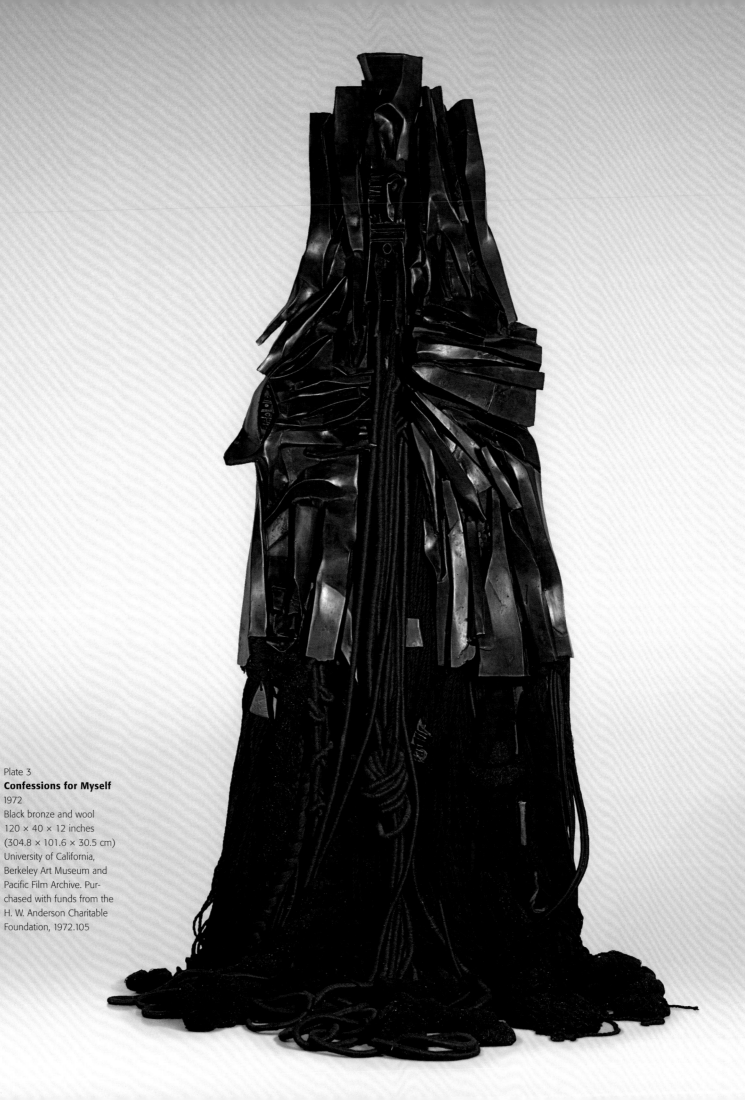

Plate 3
Confessions for Myself
1972
Black bronze and wool
120 × 40 × 12 inches
(304.8 × 101.6 × 30.5 cm)
University of California,
Berkeley Art Museum and
Pacific Film Archive. Pur-
chased with funds from the
H. W. Anderson Charitable
Foundation, 1972.105

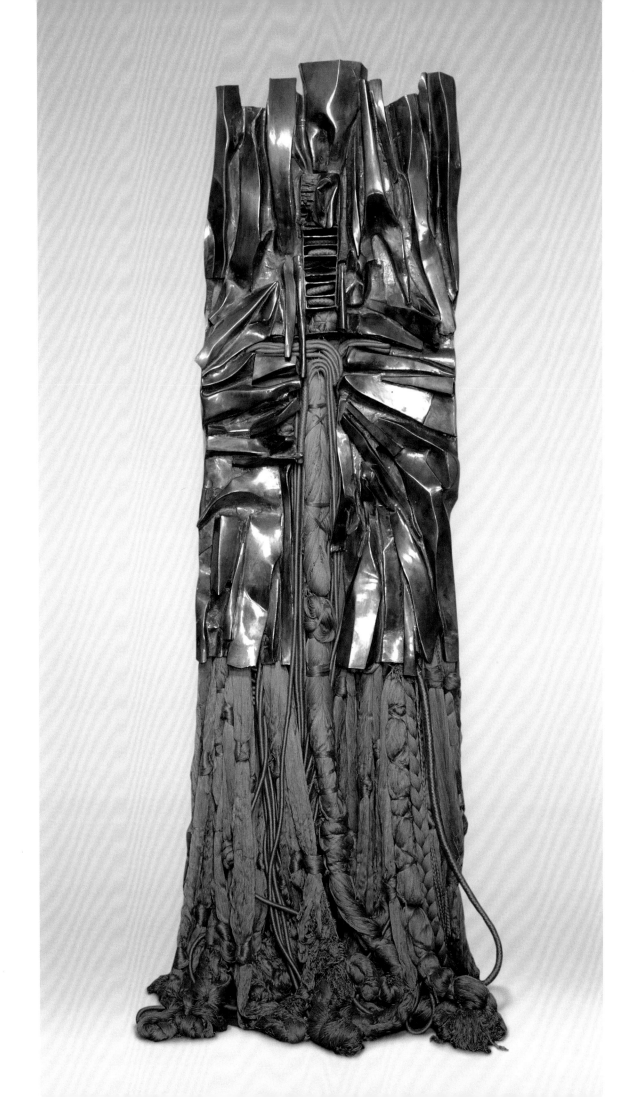

Plate 4
**All That Rises Must
Converge / Gold**
1973
Polished bronze, synthetic
silk, and silk
104 × 42 × 24 inches
(264.2 × 106.7 × 61 cm)
The Metropolitan Museum
of Art, New York. Hortense
and William A. Mohr Sculpture
Purchase Fund and Madeline
Mohr Gift, 1992.265
Image © The Metropolitan
Museum of Art. Image
source: Art Resource, NY

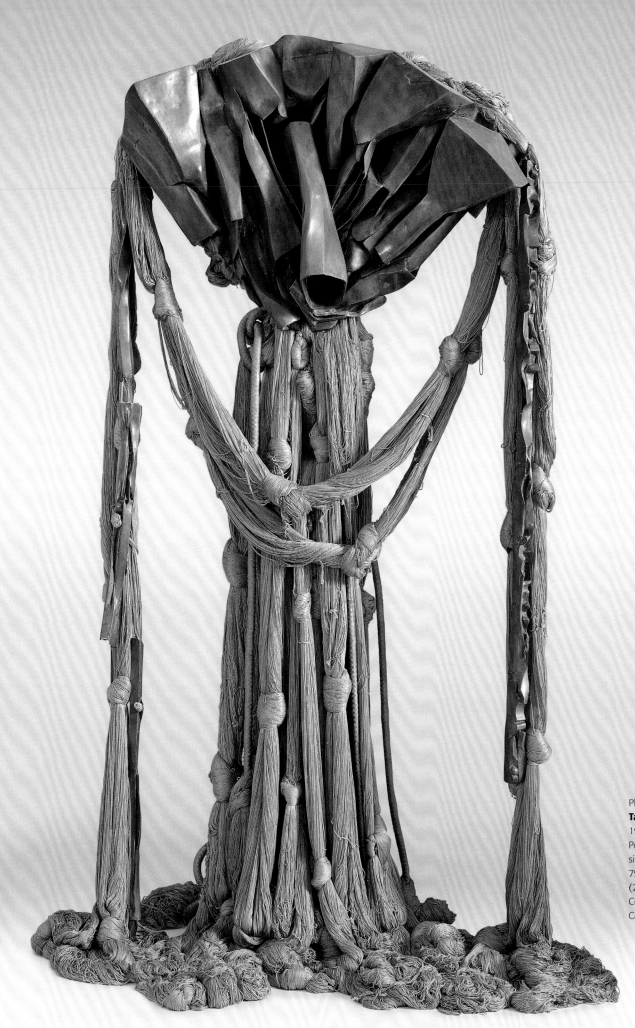

Plate 5
Tantra #1
1994
Polished bronze,
silk, and synthetic silk
79 × 52 × 32 inches
(200.7 × 132.1 × 81.3 cm)
Collection of Roger and
Caroline Ford

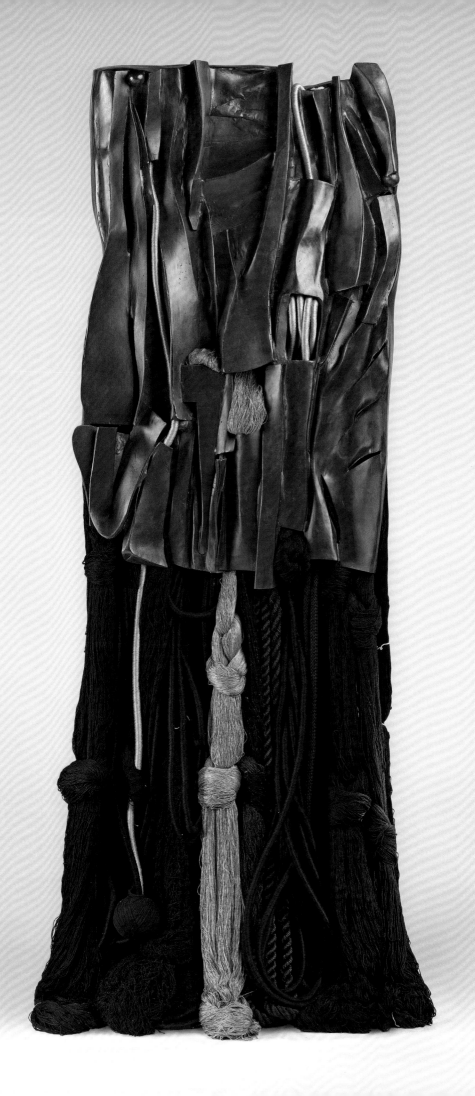

Plate 6
Malcolm X #10
2007
Black bronze, silk, wool,
and synthetic fibers
78¼ × 34 × 21 inches
(198.8 × 86.4 × 53.3 cm)
Courtesy of the artist

39

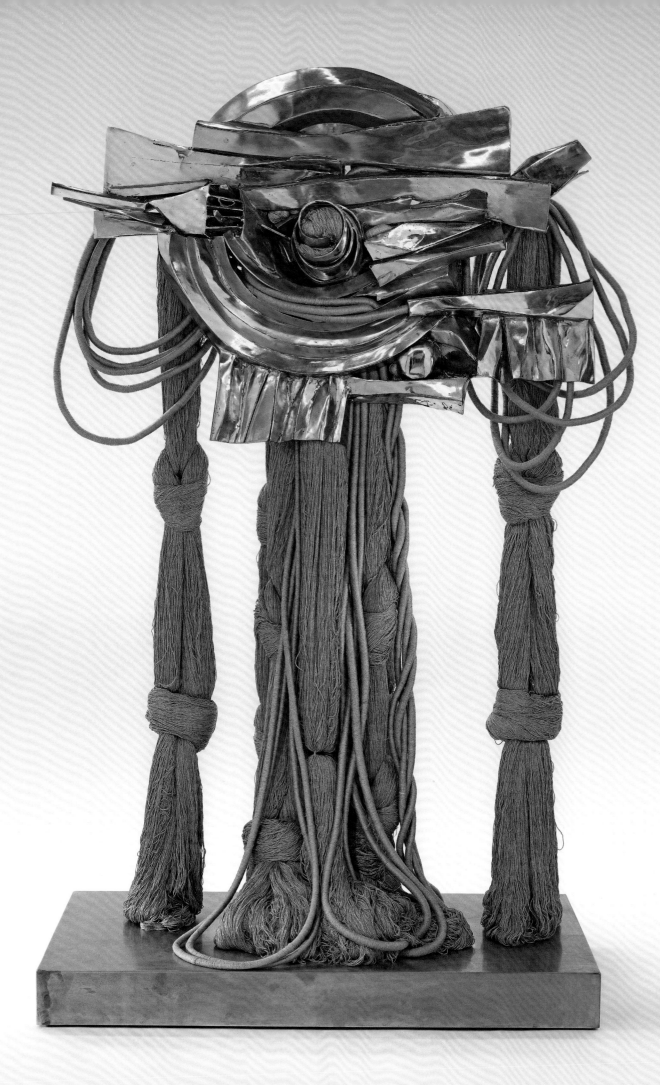

Plate 7
Tantra #4
2007–8
Polished bronze and silk
78½ × 47½ × 27¾ inches
(199.4 × 120.7 × 70.5 cm)
Courtesy of the artist

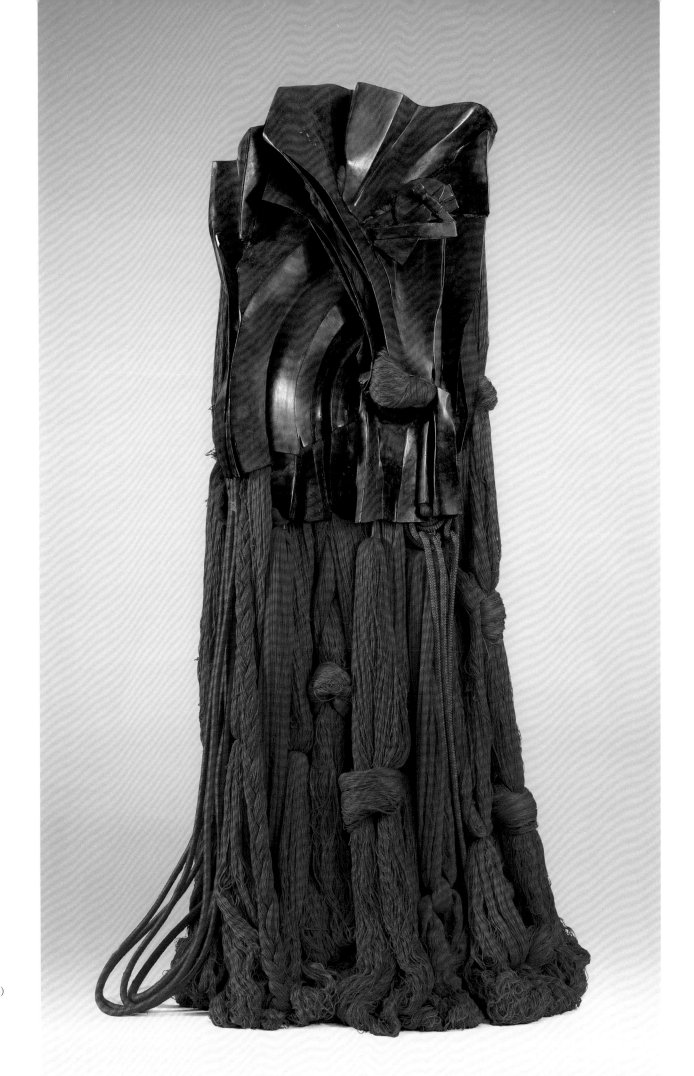

Plate 8
**All That Rises Must
Converge / Red**
2008
Red bronze, silk, and
synthetic silk
74½ × 42 × 28 inches
(189.2 × 106.7 × 71.1 cm)
Courtesy of Noel Art
Liaison, Inc.

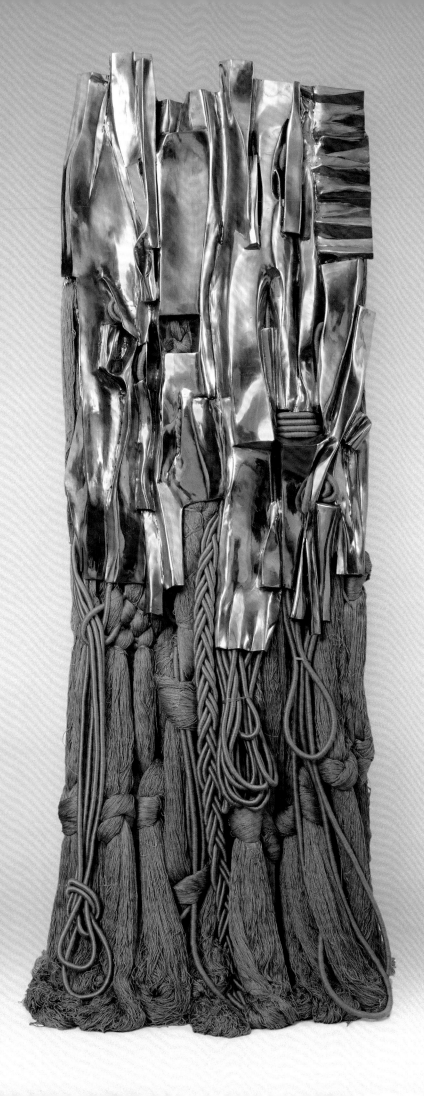

Plate 9
Malcolm X #11
2008
Polished bronze and silk
89¼ × 39 × 29 inches
(226.7 × 99.1 × 73.7 cm)
Courtesy of Noel Art
Liaison, Inc.

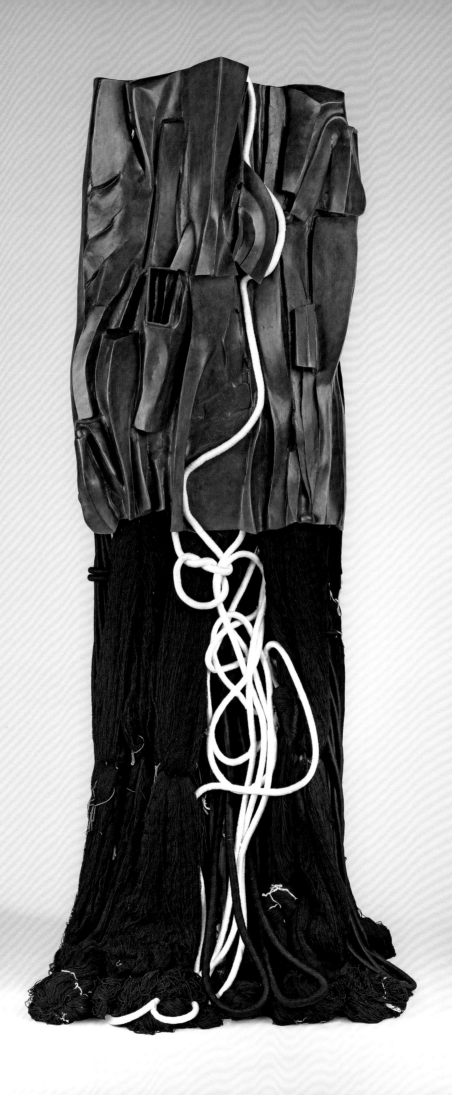

Plate 10
Malcolm X #13
2008
Black bronze, silk, wool,
linen, and synthetic fibers
86 × 36 × 25½ inches
(218.4 × 91.4 × 64.8 cm)
Courtesy of the artist

43

drawings

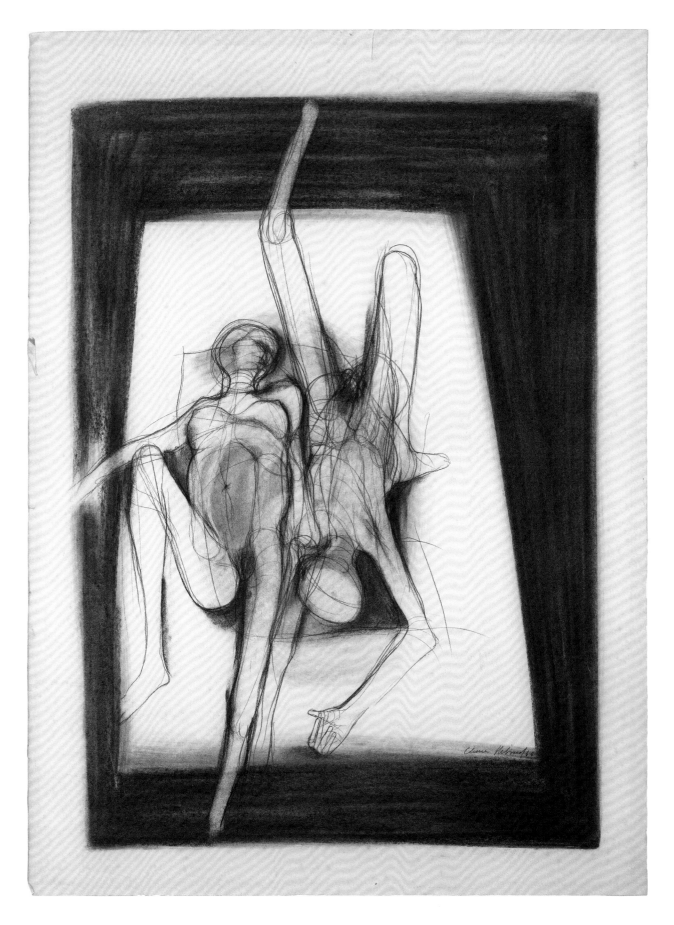

Plate 11
Le Lit (The Bed)
1966. Charcoal and charcoal pencil on paper, 29⅞ × 22⅛ inches
(75.9 × 56.2 cm). Courtesy of the artist

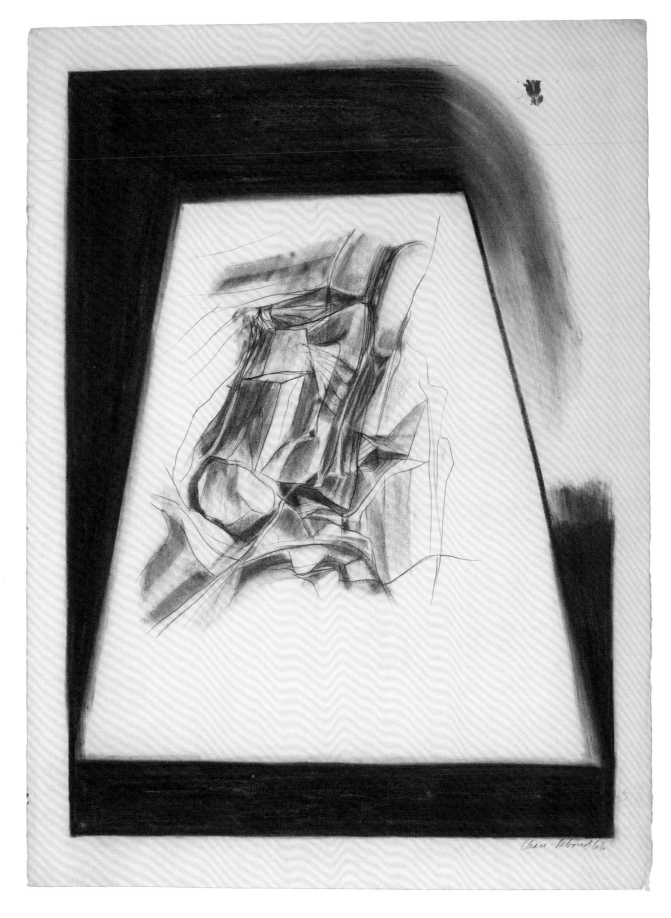

Plate 12
Le Lit (The Bed)
1966. Charcoal and charcoal pencil on paper, 30 × 22¼ inches
(76.2 × 56.5 cm). Courtesy of the artist

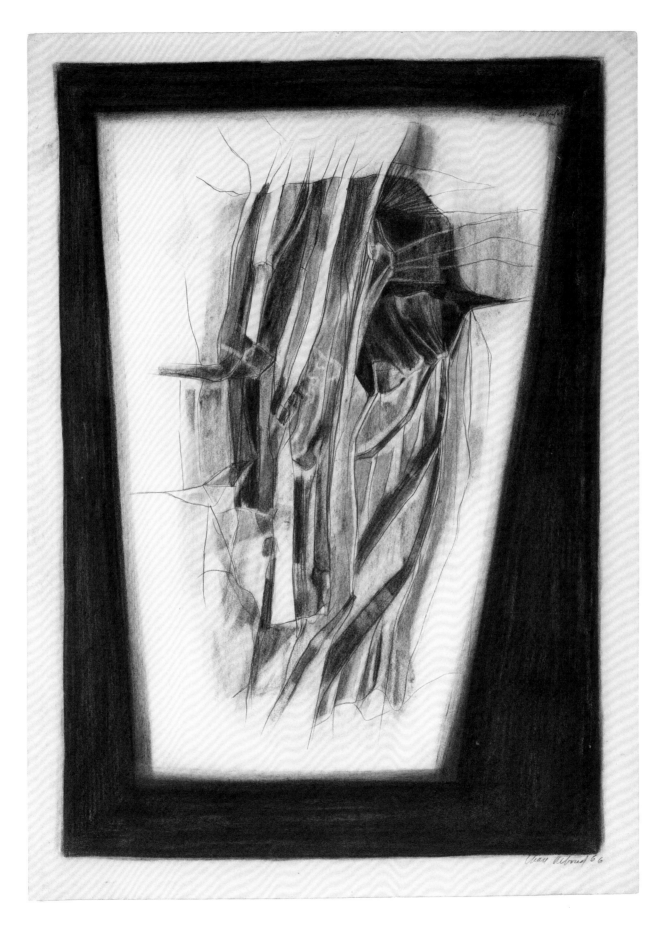

Plate 13
Le Lit (The Bed)
1966. Charcoal and charcoal pencil on paper, 30 × 22⅛ inches
(76.2 × 56.2 cm). Courtesy of the artist

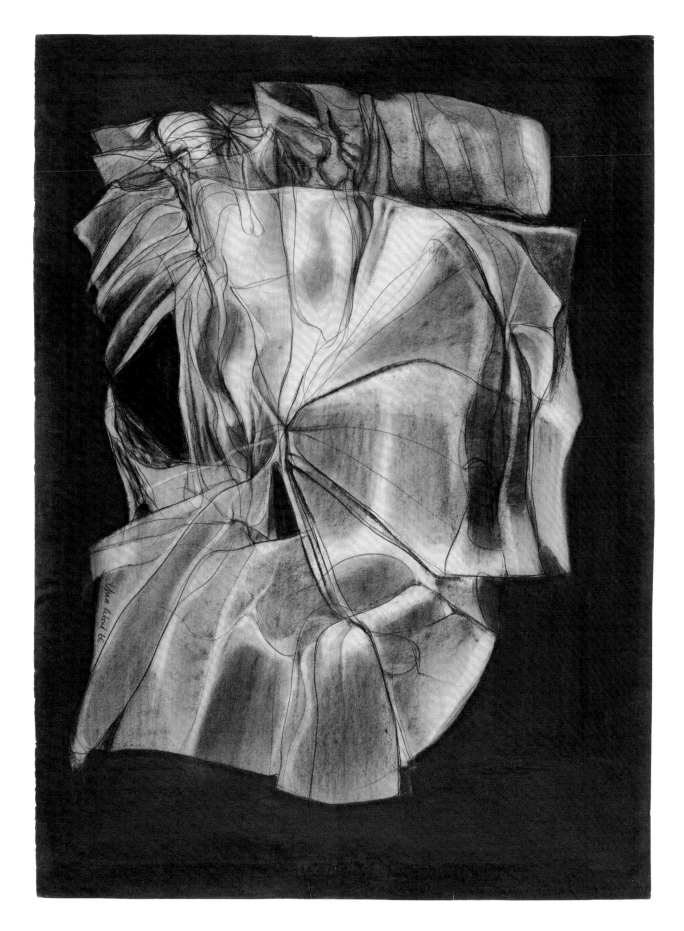

Plate 14
Le Lit (The Bed)
1966. Charcoal and charcoal pencil on paper, 29¾ × 22 inches
(75.6 × 55.9 cm). Courtesy of Noel Art Liaison, Inc.

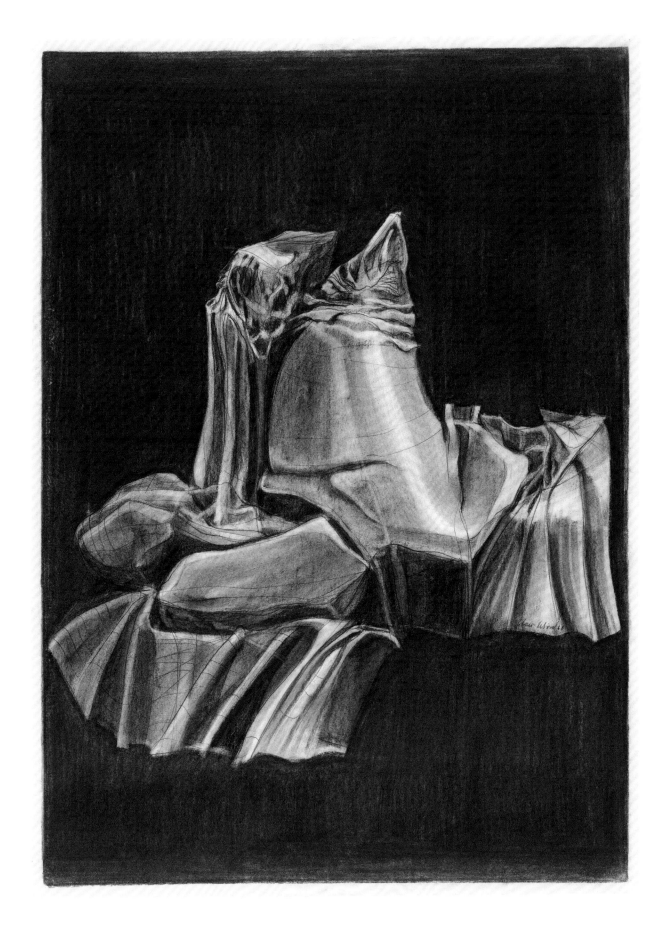

Plate 15
Untitled
1966. Charcoal and charcoal pencil on paper, 30 × 21⅞ inches (76.3 × 55.7 cm). The Museum of Modern Art, New York.
Gift of Betty Parsons Gallery, 453.1972. Digital image © The Museum of Modern Art / Licensed by SCALA / Art Resource, NY

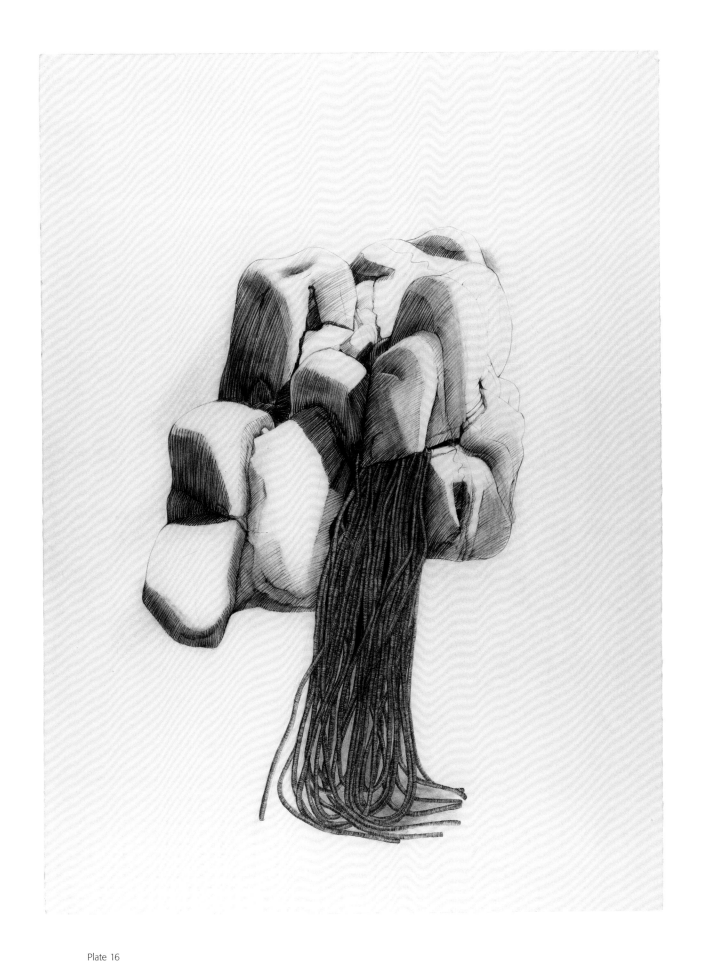

Plate 16
Untitled
1971. Charcoal and charcoal pencil on paper, 29⅞ × 22⅛ inches (76 × 56.4 cm). The Museum of Modern Art, New York. David Rockefeller Latin American Fund, 280.1972. Digital image © The Museum of Modern Art / Licensed by SCALA / Art Resource, NY

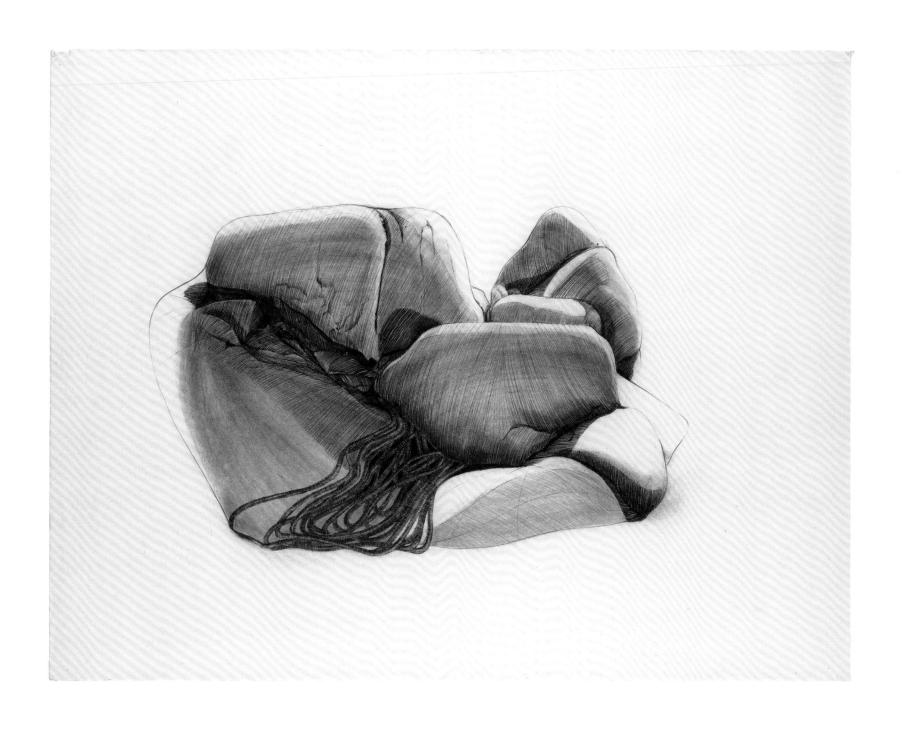

Plate 17
Untitled
1972. Charcoal on paper, 22¼ × 29¼ inches (56.5 × 74.3 cm). The Metropolitan Museum of Art, New York.
Gift of the artist, 1973.29. Image © The Metropolitan Museum of Art. Image source: Art Resource, NY

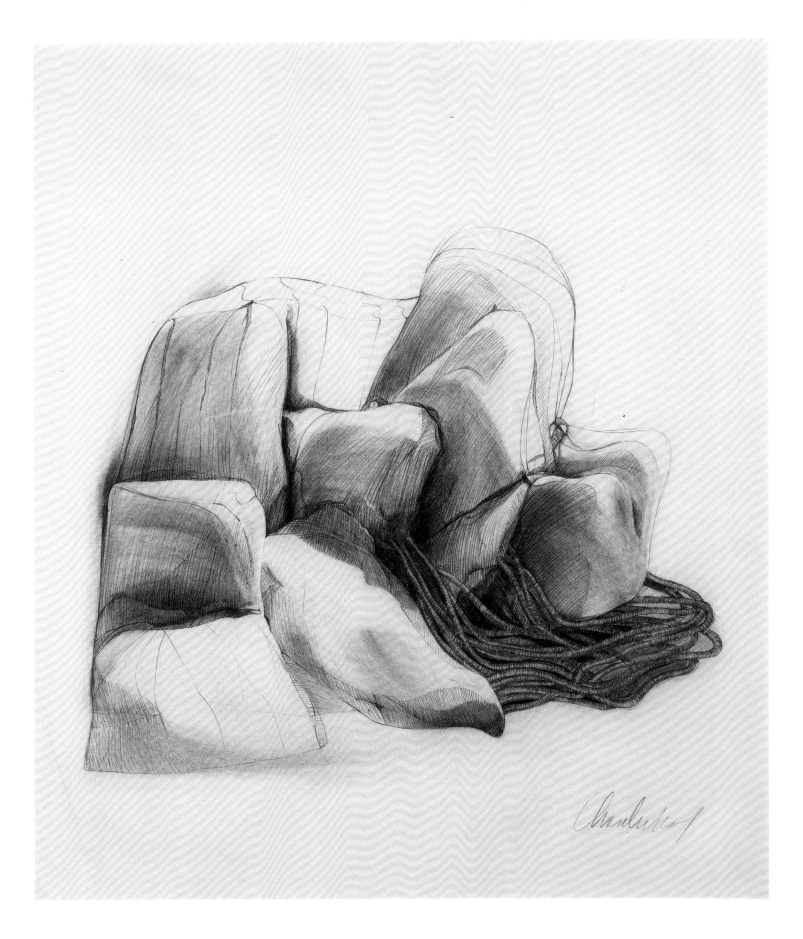

Plate 18
Landscape and Cords
c. 1973. Charcoal and charcoal pencil on paper, 22¼ × 19¾ inches
(56.5 × 50.2 cm). Courtesy of the artist

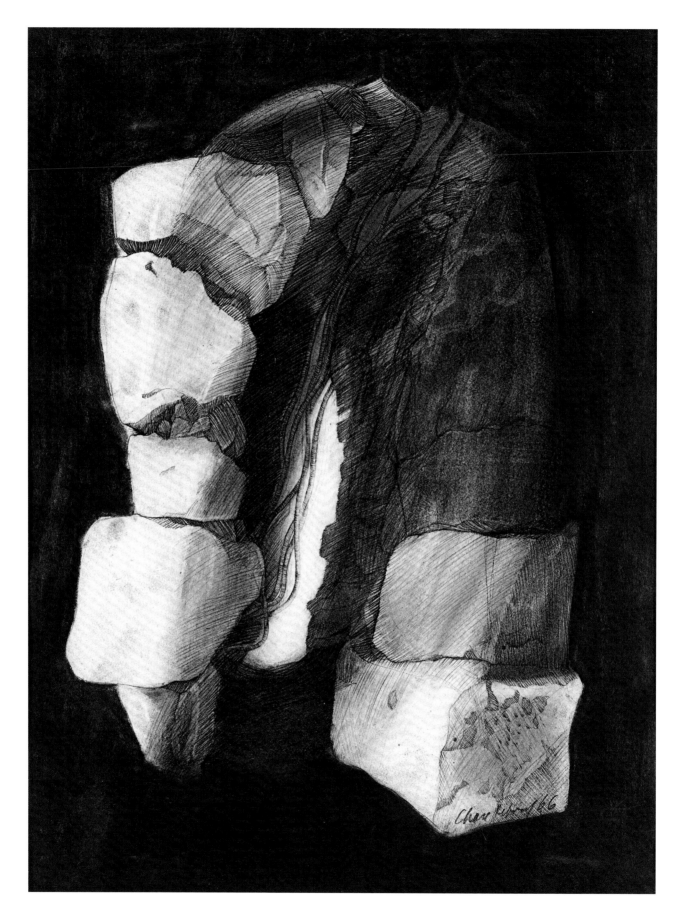

Plate 19
Untitled
1973. Charcoal and charcoal pencil on paper, 25½ × 19¾ inches
(64.8 × 50.2 cm). Mott-Warsh Collection, Flint, Michigan

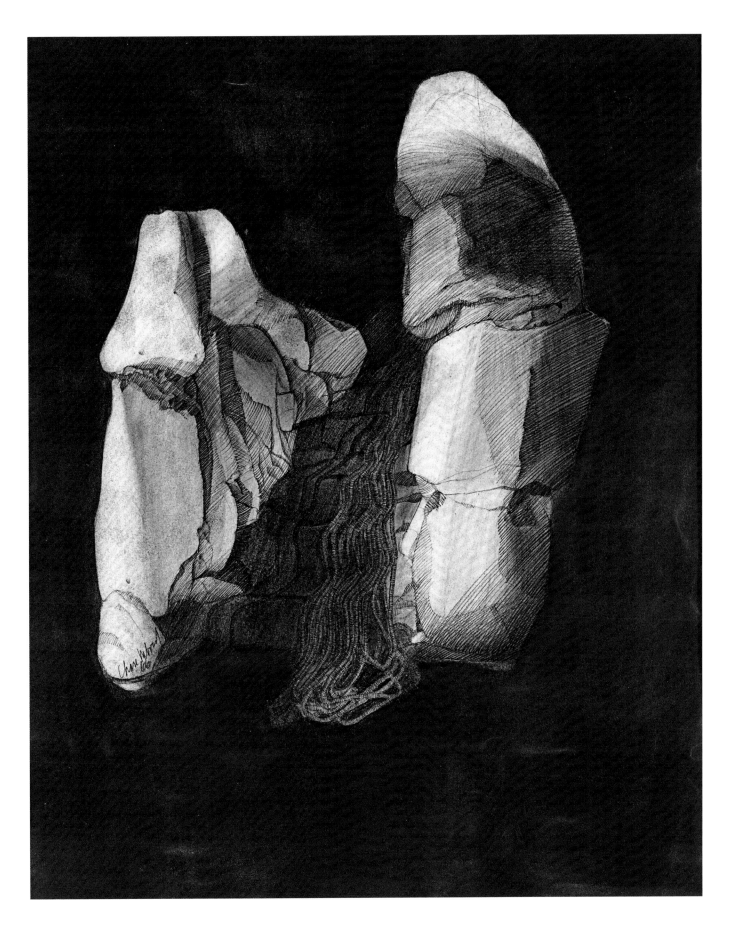

Plate 20
Untitled
1973. Charcoal and charcoal pencil on paper, 25½ × 19¾ inches
(64.8 × 50.2 cm). Mott-Warsh Collection, Flint, Michigan

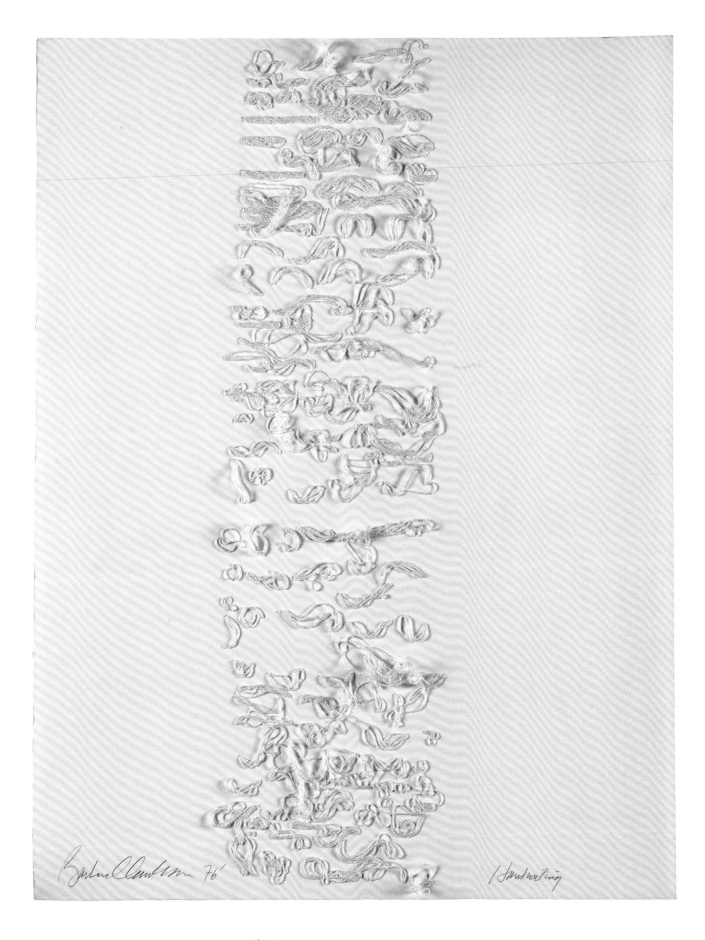

Plate 21
Handwriting
1976. Synthetic silk and paper, 25 ½ × 19 ¾ inches
(64.8 × 50.2 cm). Courtesy of the artist

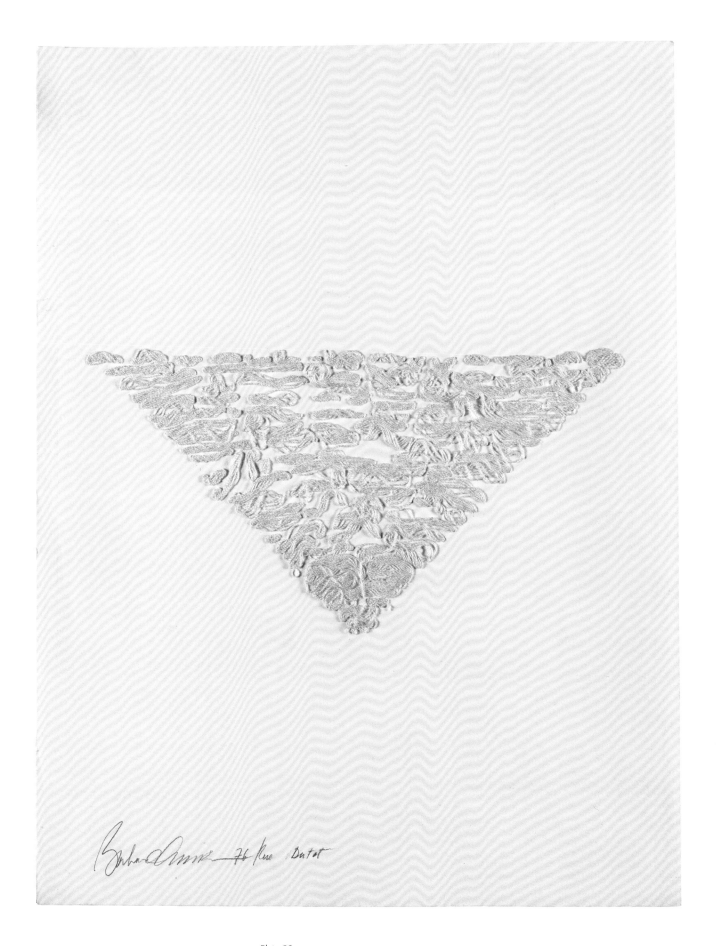

Plate 22
Rue Dutot
1976. Synthetic silk and paper, 25½ × 19⅝ inches
(64.8 × 49.8 cm). Courtesy of the artist

monument
drawings

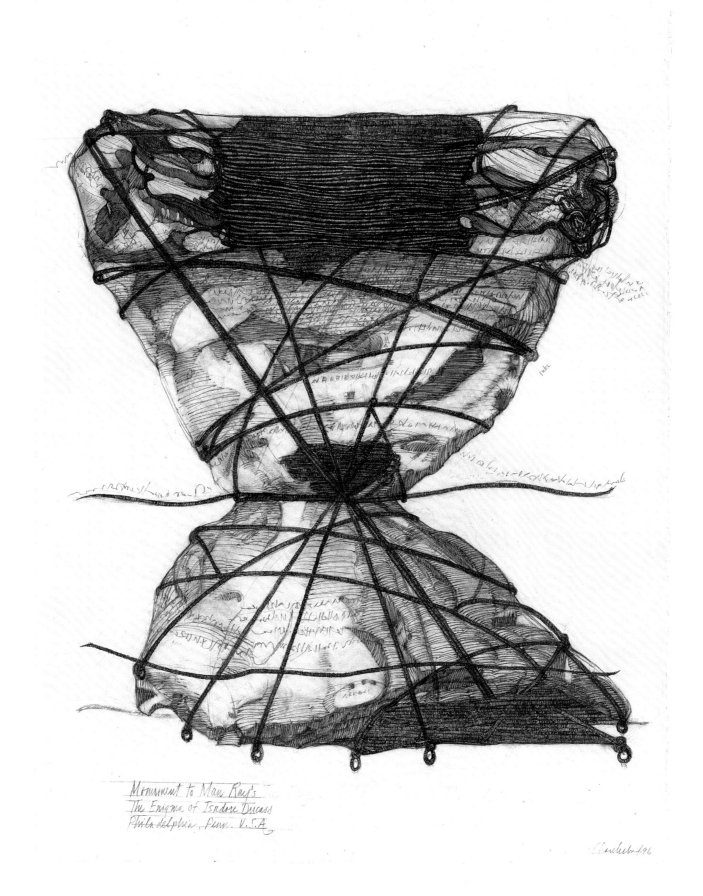

Monument to Man Ray's
The Enigma of Isidore Ducass
Philadelphia, Penn. U.S.A

Plate 23
Monument to Man Ray's "The Enigma of Isidore Ducasse," Philadelphia
1996. Etching on paper, reworked with charcoal, charcoal pencil, and pen and ink;
31½ × 23¾ inches (80 × 60.3 cm). Courtesy of the artist

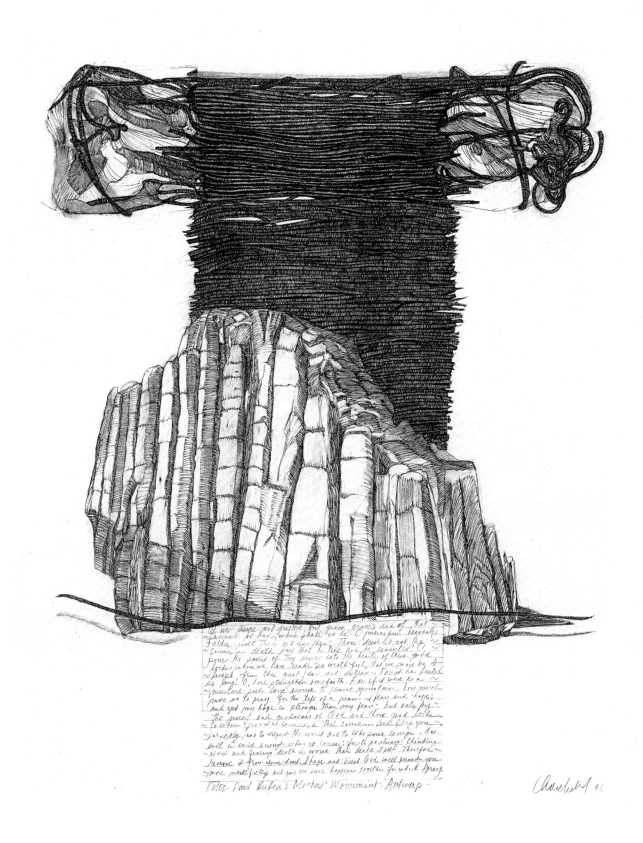

Plate 24
Peter Paul Rubens's Mother's Monument, Antwerp
1996. Etching on paper, reworked with charcoal, charcoal pencil, and pen
and ink; 31½ × 23¾ inches (80 × 60.3 cm). Courtesy of the artist

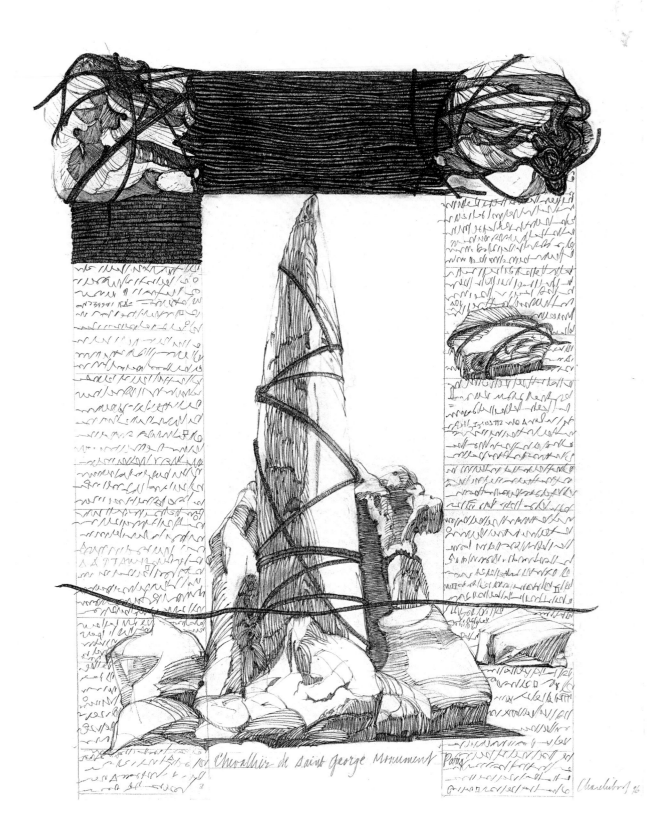

Plate 25
Chevalier de Saint-George Monument, Paris
1996. Etching on paper, reworked with charcoal, charcoal pencil, and
pen and ink; 31½ × 23⅞ inches (80 × 60.6 cm). Courtesy of the artist

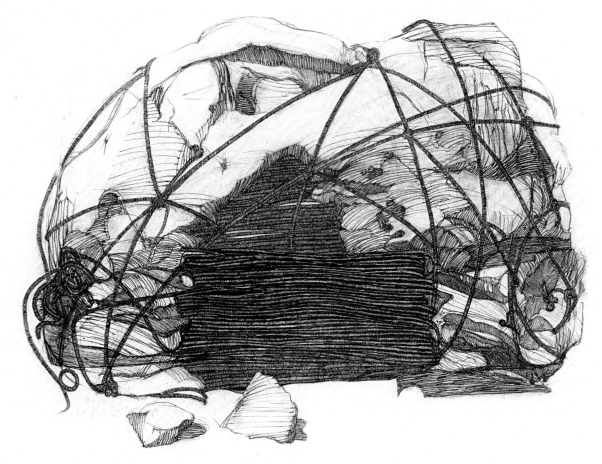

Cardinal Ricci Monument, Palazzo Ricci. Rome Chashibay 96

Plate 26
Cardinal Ricci Monument, Palazzo Ricci, Rome
1996. Etching on paper, reworked with charcoal, charcoal pencil, and
pen and ink; 31½ × 23⅞ inches (80 × 60.6 cm). Courtesy of the artist

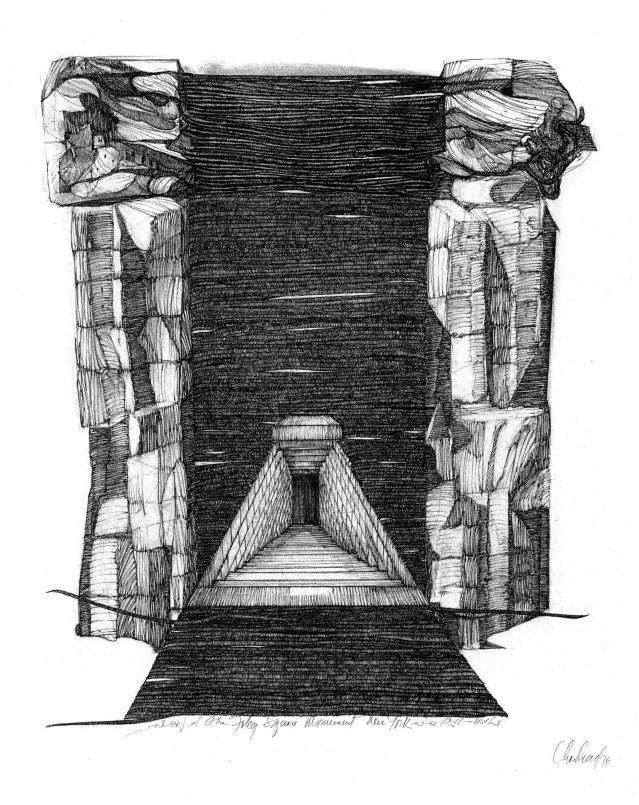

Plate 27
The Foley Square Monument, New York
1996. Etching on paper, reworked with charcoal, charcoal pencil, and
pen and ink; 31½ × 24 inches (80 × 61 cm). Courtesy of the artist

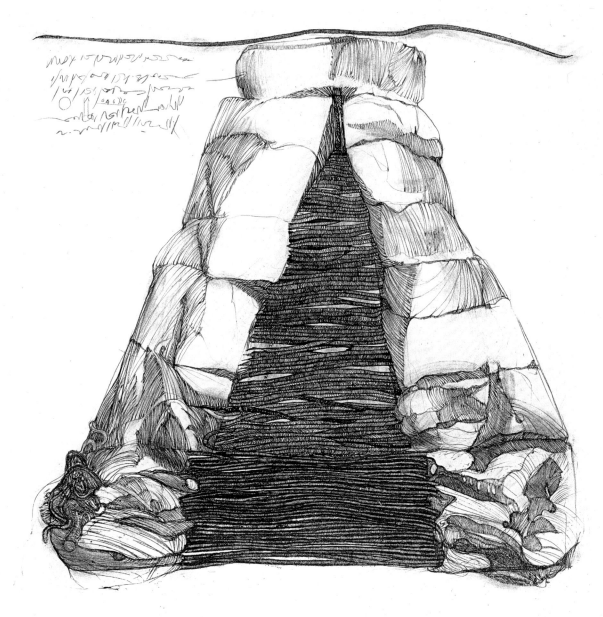

Plate 28
Monument of Sheshonq II, Cairo
1996. Etching on paper, reworked with charcoal, charcoal pencil, and
pen and ink; 31½ × 23¾ inches (80 × 60.3 cm). Courtesy of the artist

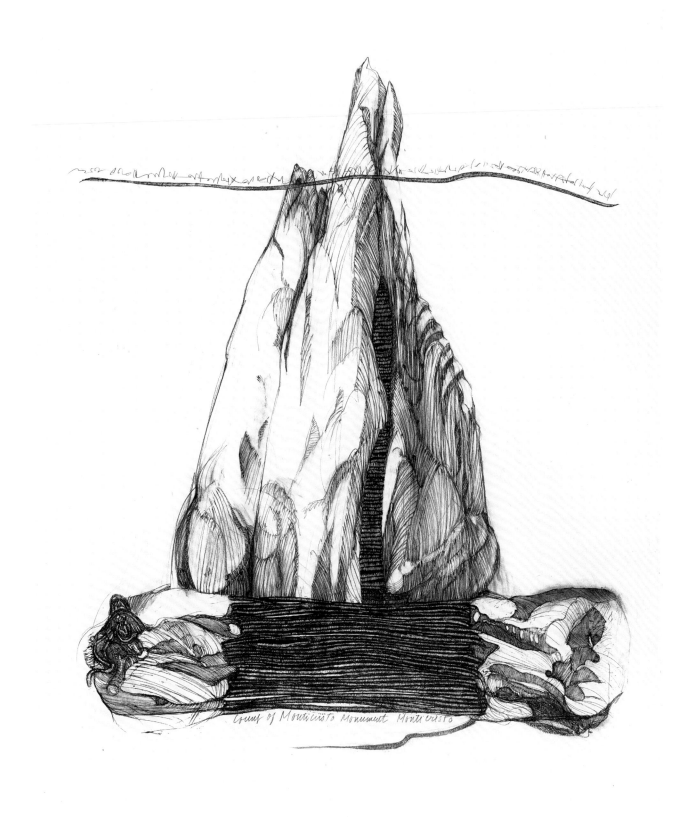

Count of Monticristo Monument Monticristo

Plate 29
Count of Monte Cristo Monument, Monte Cristo
1996. Etching on paper, reworked with charcoal, charcoal pencil, and
pen and ink; 31½ × 23¾ inches (80 × 60.3 cm). Courtesy of the artist

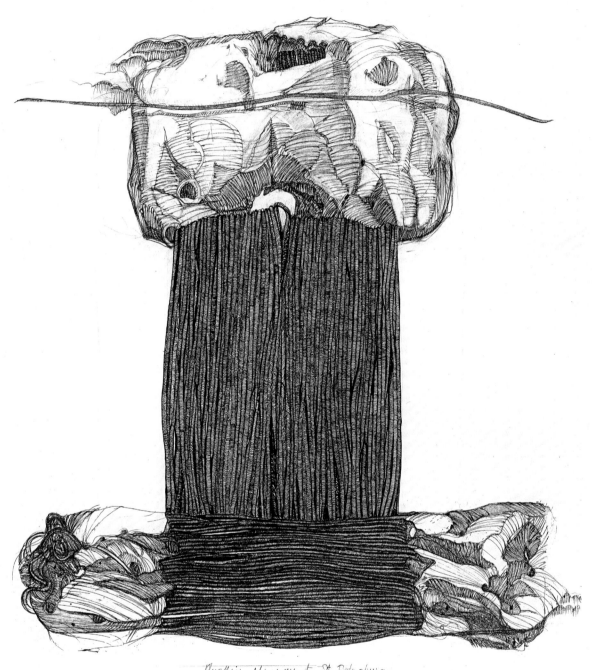

Pushkin Monument, St. Petersburg

Chachatun 96

Plate 30
Pushkin Monument, St. Petersburg
1996. Etching on paper, reworked with charcoal, charcoal pencil, and
pen and ink; 31½ × 23¾ inches (80 × 60.3 cm). Courtesy of the artist

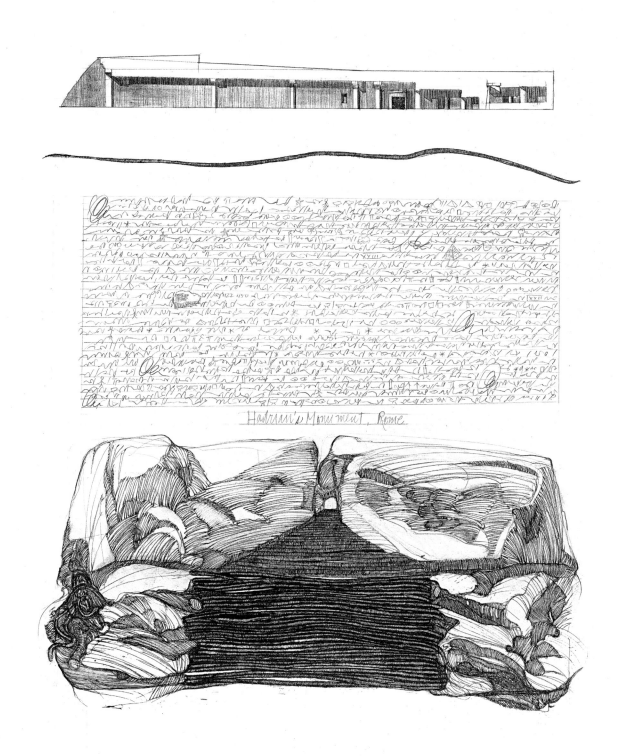

Hadrian's Monument, Rome

Plate 31
Hadrian's Monument, Rome
1996. Etching on paper, reworked with charcoal, charcoal pencil, and
pen and ink; 31½ × 23⅞ inches (80 × 60.6 cm). Courtesy of the artist

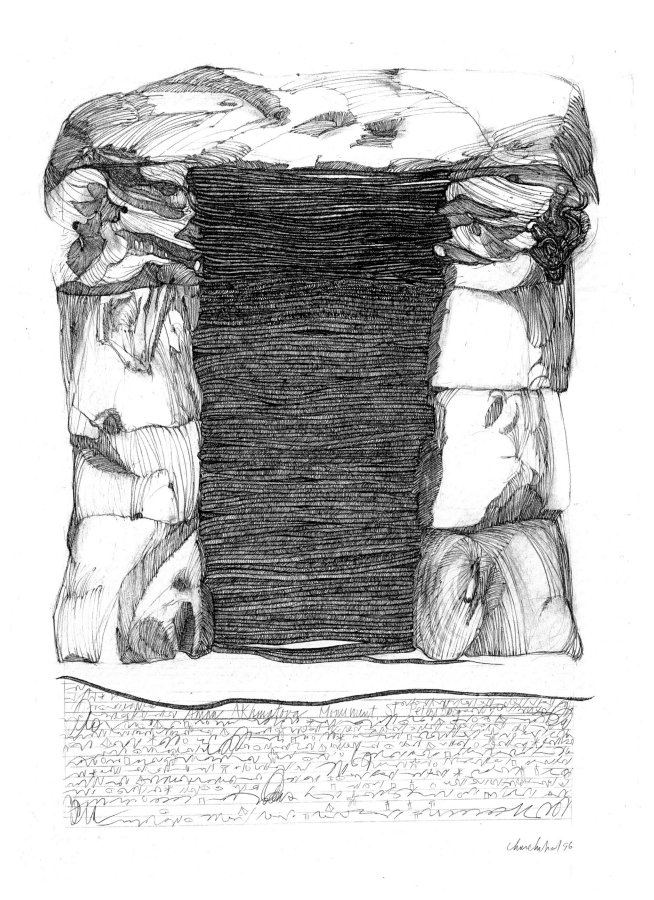

Plate 32
Anna Akhmatova Monument, St. Petersburg
1996. Etching on paper, reworked with charcoal, charcoal pencil, and
pen and ink; 31½ × 23¾ inches (80 × 60.3 cm). Courtesy of the artist

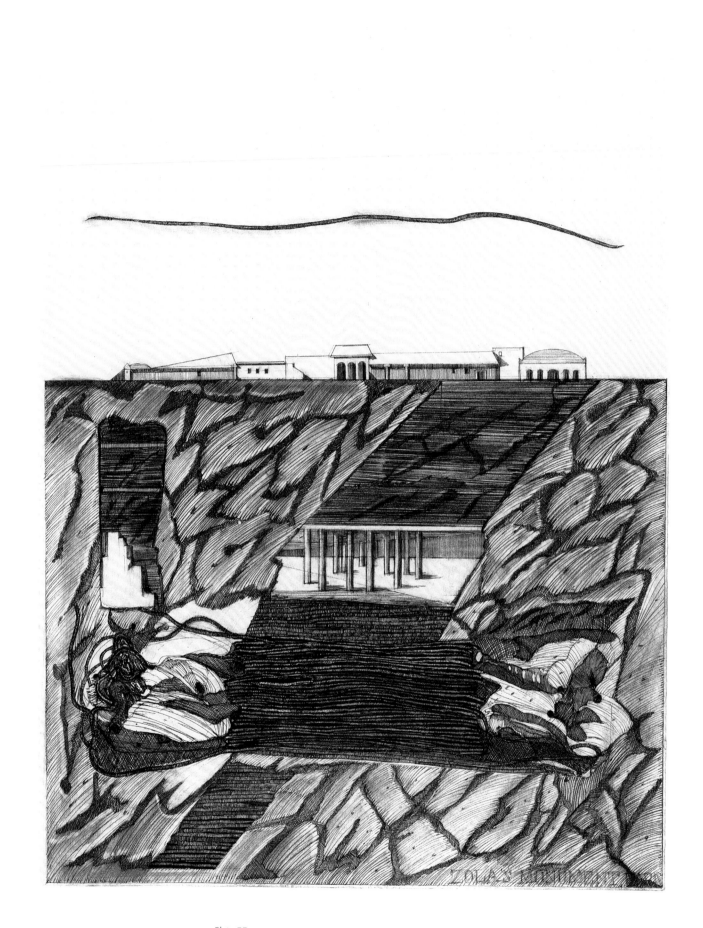

Plate 33
Zola's Monument, Paris
1997. Etching on paper, reworked with charcoal, charcoal pencil, and
pen and ink; 31½ × 23¾ inches (80 × 60.3 cm). Courtesy of the artist

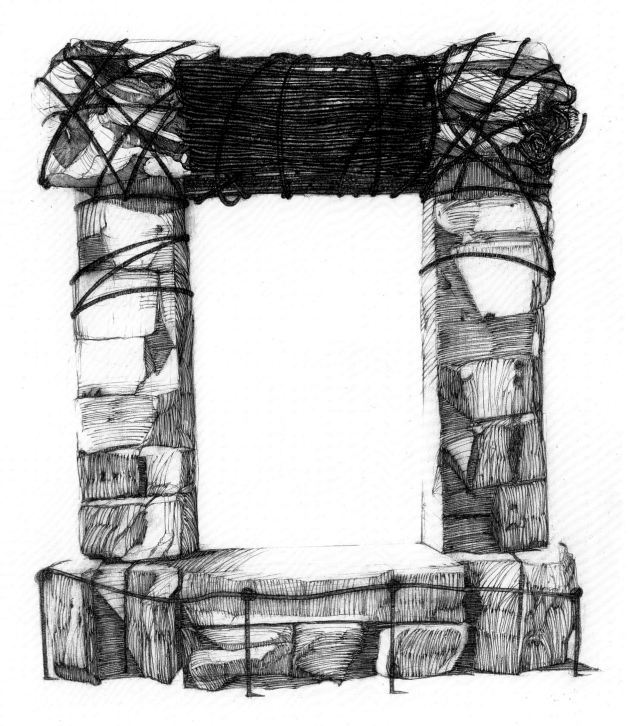

Middle Passage Monument, Washington

Plate 34
Middle Passage Monument, Washington
1997. Etching on paper, reworked with charcoal, charcoal pencil, and
pen and ink; 31½ × 23⅞ inches (80 × 60.6 cm). Courtesy of the artist

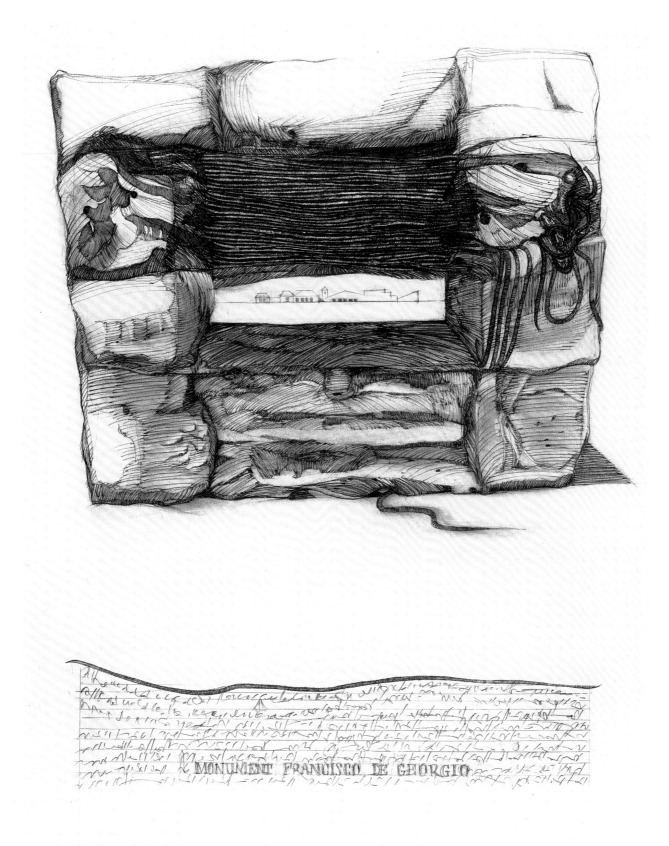

Plate 35
Monument Francesco di Giorgio, Florence
1997. Etching on paper, reworked with charcoal, charcoal pencil, and
pen and ink; 31½ × 23⅞ inches (80 × 60.6 cm). Courtesy of the artist

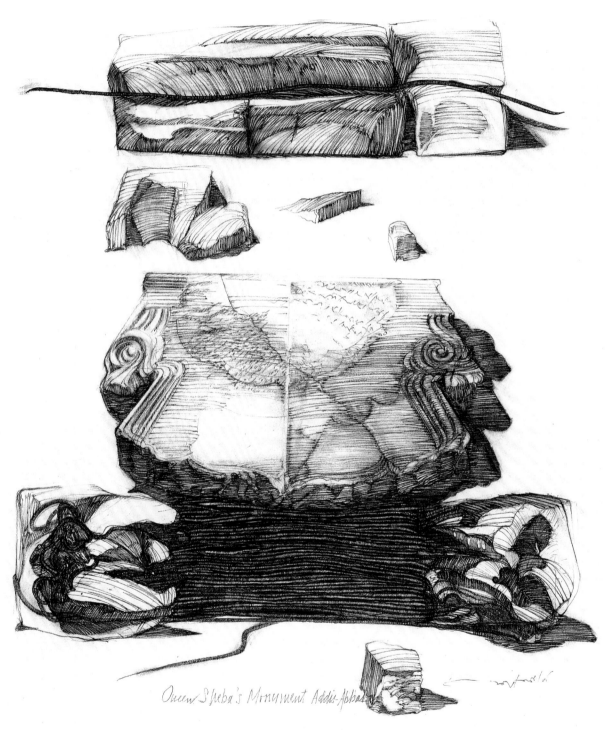

Queen Sheba's Monument Addis-Abbas

Plate 36
Queen Sheba's Monument, Addis Ababa
1997. Etching on paper, reworked with charcoal, charcoal pencil, and
pen and ink; 31½ × 23¾ inches (80 × 60.3 cm). Courtesy of the artist

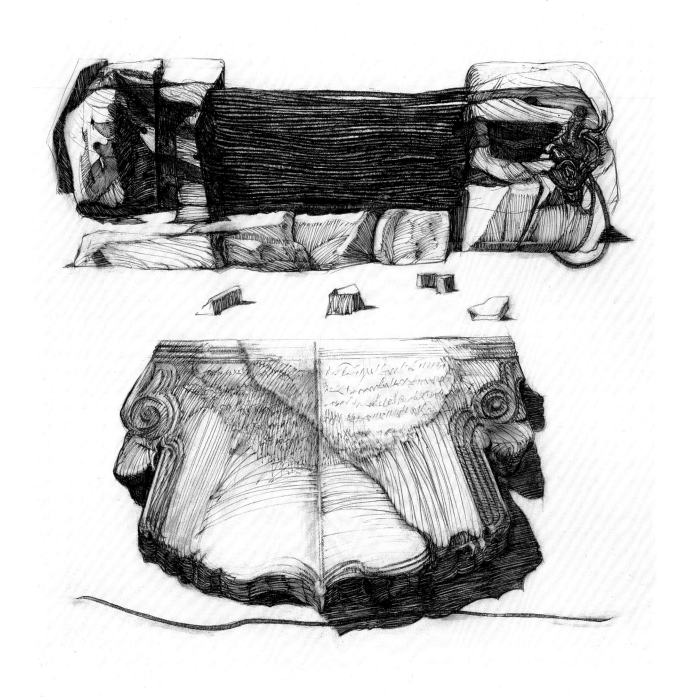

Queen Sheba & King Soloman Monument..Jerusalem

Charles Troy 97

Plate 37
Queen Sheba and King Solomon Monument, Jerusalem
1997. Etching on paper, reworked with charcoal, charcoal pencil, and
pen and ink; 31½ × 23⅞ inches (80 × 60.6 cm). Courtesy of the artist

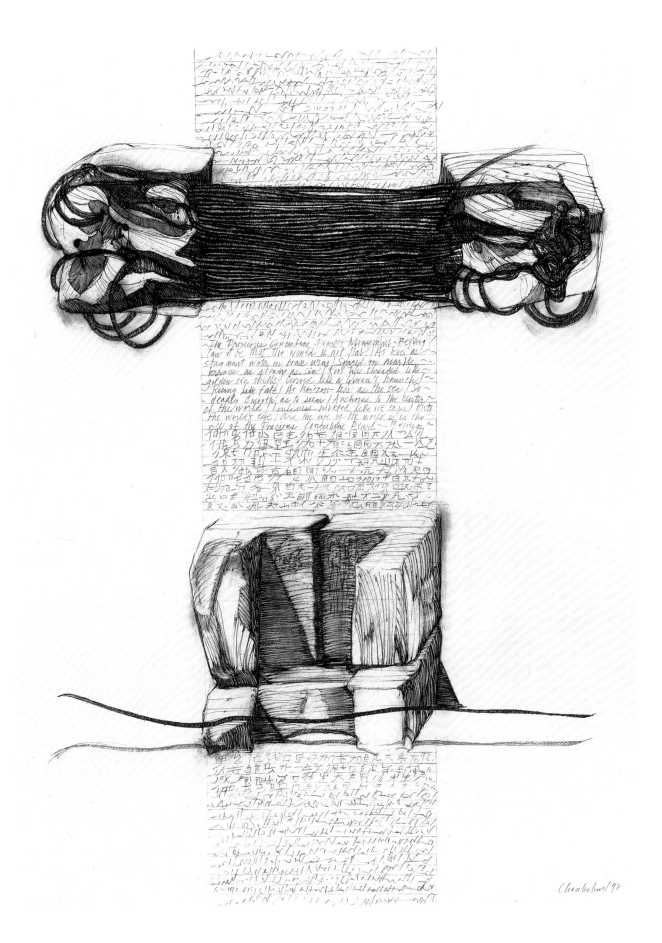

Plate 38
The Precious Concubine Pearl's Monument, Beijing
1997. Etching on paper, reworked with charcoal, charcoal pencil, and
pen and ink; 31½ × 23⅞ inches (80 × 60.6 cm). Courtesy of the artist

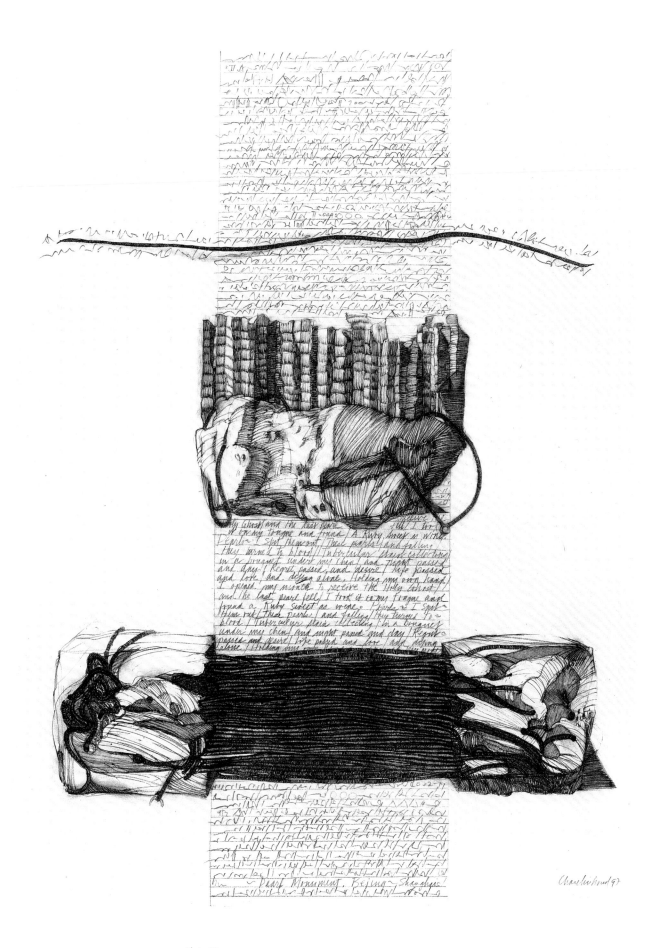

Plate 39
Pearl Monument, Beijing–Shanghai
1997. Etching on paper, reworked with charcoal, charcoal pencil, and
pen and ink; 31½ × 23⅞ inches (80 × 60.6 cm). Courtesy of the artist

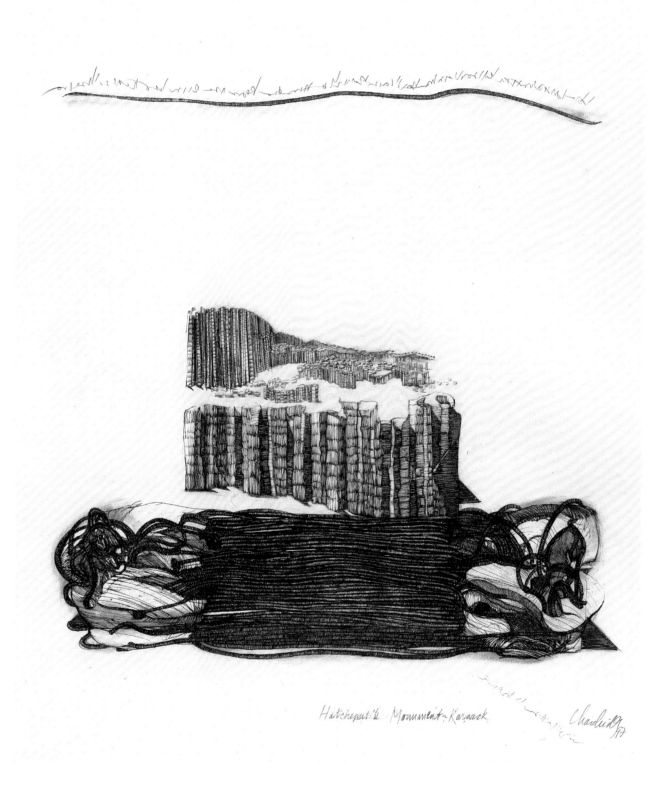

Plate 40
Hatshepsut's Monument, Karnak
1997. Etching on paper, reworked with charcoal, charcoal pencil, and
pen and ink; 31½ × 23⅞ inches (80 × 60.6 cm). Courtesy of the artist

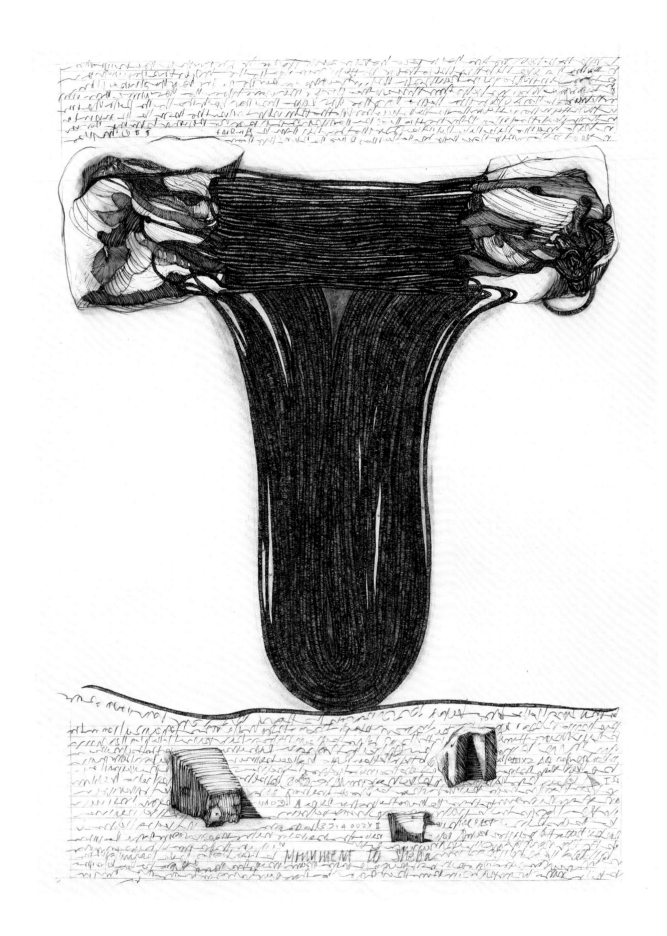

Plate 41

Monument to Sheba

c. 1997. Etching on paper, reworked with charcoal, charcoal pencil, and pen
and ink; 31½ × 23¾ inches (80 × 60.3 cm). Courtesy of Noel Art Liaison, Inc.

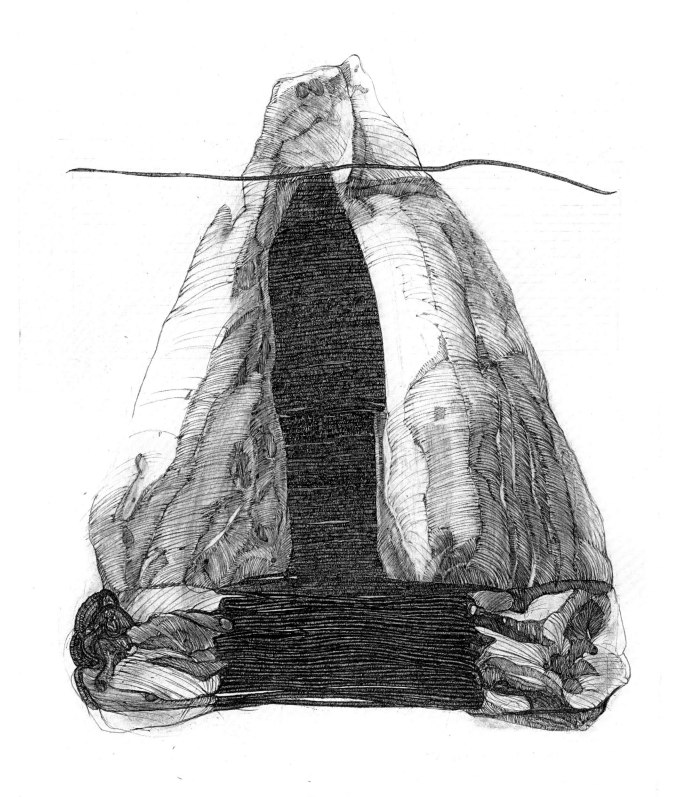

Monument To Oscar Wilde—"To reveal art and conceal the artist is art's aim" Chase [illegible] 2011

Plate 42
Monument to Oscar Wilde
2011. Etching on paper, reworked with charcoal, charcoal pencil, and pen
and ink; 30⅞ × 23¾ inches (78.4 × 60.3 cm). Courtesy of the artist

The *Malcolm* Steles
and the Silenced X

Barbara Chase-Riboud

The text that follows was written by the artist as a lecture on the occasion of the exhibition **Barbara Chase-Riboud: The *Malcolm X* Steles** *at the Philadelphia Museum of Art.*

Today, with the X in Malcolm X silenced by hero worship, revisionism, and the national tribute to his memory of the United States Postal Service's thirty-three-cent stamp, it is hard to imagine the furor that began by my dedication of these cerebral, highly baroque, and defiantly beautiful steles of the 1970s memorializing the assassinated civil rights leader. But the X was already silenced then for my purpose, which was that of illustrating the literaturation of abstract expressionism that began with Jasper Johns's *Flag* (1954–55) and Robert Rauschenberg's *Canyon* (1959) and ended with Francis Bacon's *Portrait of Henrietta Moraes* (1963) (figs. 1–3).

Rauschenberg's *Canyon*, which is neither sculpture nor painting but a collage, took abstraction in the direction of literature (the object), just as Johns took the object (the flag) into the realm of flat canvas abstraction. Bacon took the human figure into the realm of flat abstraction and then reinvented it back into spatial representation.

The story of the literaturation of my surrealistic sculptures of the 1960s into the abstraction of the *Malcolm* steles was twofold: First, there was its abstraction into a three-dimensional relief surface of baroque folds and cuts, which was only possible with a technique known as lost wax, and then its abstraction back onto this sculptural surface as writing or drawing by combining cast bronze and silk fibers into metaphor.

At this point, let me backtrack to Rome, 1958, and my discovery of the lost wax process of bronze casting in which liquid wax is used to reproduce a cast of a plaster or clay model, which is then reproduced by melting out the wax in the mold and replacing it with molten bronze. This was the method I used until, one day, thanks to my workers, I discovered direct wax, in which liquid wax is modeled directly onto an armature and a sand-and-cement core without the intermediary of a mold of the plaster model or object. This had been the classic procedure of bronze casting since Greek, Egyptian, and Ashanti times. Wax was part of the process of reproduction, not an end in itself.

The nineteenth-century Italian Medardo Rosso was the first modern sculptor to use this method to achieve impressionistic sculpture that approximated the effect of the impressionist painters' exploration of light by breaking up the surface of the wax into tiny fragments of flowing form whose play of light became almost motion, so active was the wax surface (fig. 4). In Rome, I discovered the classical technique of lost wax, but also the amazing possibility of sculpting directly with thin sheets of wax that could be folded or cut to inform abstract forms of great intricacy and baroqueness, in contrast to the Giacometti-like plastered surfaces I had made up until that time (figs. 5, 6).

I could slash, fold, melt, chew, force, and form these relatively light, highly pliable sheets into deep cuts and undercut spaces that were impossible to achieve with a mold. Yet the wax is strong enough and hard enough to be worked into very baroque forms without the core of sand or cement, allowing those forms to be scaffolded into a span almost without limit to achieve these undercuts, curves, and fingerprint-sensitive surfaces, which are welded together in an almost Arabic or Oriental fretwork.

These castings were extremely dangerous and delicate to accomplish since there was no model remaining at the end of the process. If the direct wax failed to cast, you had lost your sculpture for good. Only the skill of the foundry workers stood between you and catastrophe. That and pure intuition. If the wax was too hard, too soft, too thin in places, or too thick; if the bronze was too turbid to pour, too hot, too cold, too vaporous; if the sun was shining, or the moon was in its wrong stage/phase; if the amount of iron or copper was too much or too little or too late, you had lost weeks and months

Fig. 1. Jasper Johns (American, born 1930). *Flag*, 1954–55. Encaustic, oil, and collage on fabric mounted on plywood, three panels; 42¼ × 60⅝ inches (107.3 × 153.8 cm). The Museum of Modern Art, New York. Gift of Philip Johnson in honor of Alfred H. Barr, Jr., 106.1973. Digital image © The Museum of Modern Art / Licensed by SCALA / Art Resource, NY

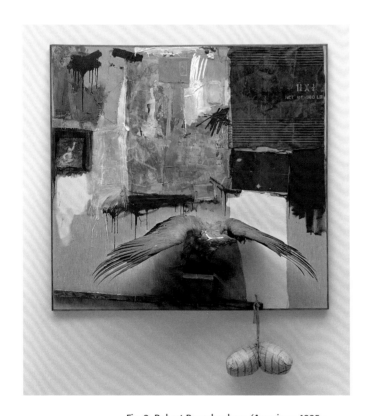

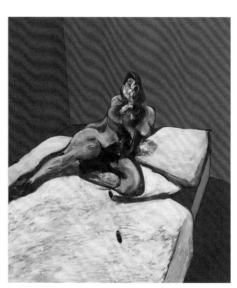

Fig. 3. Francis Bacon (British, 1909–1992). *Portrait of Henrietta Moraes*, 1963. Oil on canvas, 65 × 56 inches (165 × 142 cm). Private collection

Fig. 2. Robert Rauschenberg (American, 1925–2008). *Canyon*, 1959. Oil, pencil, paper, metal, photograph, fabric, wood, canvas, buttons, mirror, taxidermied eagle, cardboard, pillow, paint tube, and other materials; 81¾ × 70 × 24 inches (207.6 × 177.8 × 61 cm). The Museum of Modern Art, New York. Gift of the family of Ileana Sonnabend, 1782.2012. Digital image © The Museum of Modern Art / Licensed by SCALA / Art Resource, NY

of work and preparation and there was no appeal—you had a mess of twisted metal. Since there was no possibility of an edition with this method, the sculpture was unique—a one-of-a-kind bronze.

Up until now, I have never lost a sculpture, although I have had some close calls.

Now my next problem was to completely divert these abstractions from any naturalistic or surrealistic appearance. In other words, the "legs" had to go. But then how could these arabesques be kept off the floor or not attached to a base? I thought of a screen to hide the armature, but how to do this without falling into the folklore of Oceanic, African, or Japanese dancing masks? What about a material that was in itself both ancient and modern, both alive and in motion—thread that solidified but was never completely static, never completely still, like grass. Thread that was as strong as steel.

The sculptures were by necessity low relief, worked on the floor in an accumulative manner, and the element of ever-changing light took on a primordial importance. But as the silk took on the light of the polished bronze, and the bronze took on the reflection of the same color silk, an amazing thing happened—the form was lifted vertically and the skirt of silk fiber collaged into it.

Suddenly there was a combustion of interaction between the cast, polished or black bronze and the soft, implied motion of the skirt, which took on the characteristics of the bronze, solidifying into a column of graphic line and mass that seemed to support the metal, while the bronze melted into a soft mass of interacting light in motion. The materials had come to some kind of unplanned peace treaty on their own and fused into one entity. Alchemy or chance? As this happened in case after case (but not always), I fig-

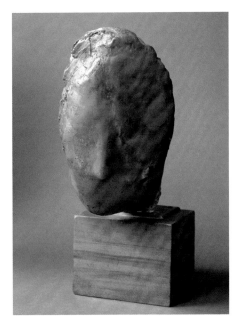

Fig. 4. Medardo Rosso (Italian, 1858–1928). *Madame X*, 1896. Wax on plaster, 11¹³⁄₁₆ × 7½ × 9½ inches (30 × 19 × 24 cm). Galleria Internazionale d'Arte Moderna di Ca' Pesaro, Venice. Archivio Fotografico – Fondazione Musei Civici di Venezia, 2013

ured it was luck but not happenstance. I had my steles. I decided to dedicate them to the assassinated civil rights leader Malcolm X.

A word about the metamorphosis of the "soft" silk into solidity and the "hard" bronze into fluidity. In the collage of these materials, there occurs the alchemy of metamorphosis, as the British painter Frank Bowling would put it—a celebration of the impure coalescence or collision of materials that can both signify and undermine time-honored ideas about abstraction. The first time it happened, I was astounded. Then I realized it would happen every time if I was very careful—and that this phenomenon had revelatory importance to the sculpture and what I was trying to do. The combination of these elements took abstraction in a new and entirely original

direction. The transformation of the materiality of the two opposing elements had produced a third materiality neither hard nor soft, black nor white, male nor female, totally visual nor totally literary. The transportation was the message and the response, just as Bacon's transformation of flesh was both the message and the response, making his third-hand manifestation both material and philosophical.

One could say this kind of action or collage almost always occurs in moments of transition or transfiguration in art. As early as the fifteenth century you have the emotionalization of surface, as in the case of Fra Angelico's *Virgin of Humility* (fig. 7), where collage occurs between the flat decoration of the Virgin's circular gold throne and the folded, draped, creased perspective of the Fra Angelico blue mantle that protrudes from the surface as real cloth, creating both a metaphysical change in the painting as well as a psychological, visual, and philosophical one in that this is a turning point in the use of painted surfaces as pure emotion.

This coexistence of collage and abstraction and the emotionalization of surface brings me back to these *Malcolm* steles (with the *X* silent) and the idea of the literaturation of the sculpted surface as drawing and writing. If the silk is drawing and writing, and the bronze surface is made out of wax that can be written on, even by a fingerprint or a drop of melted wax, then the whole surface becomes literate—or at least has a certain kind of literacy, written with a stylus on wax as calligraphic notations or imaginary writing. My signature drawing began with the *Hopscotch Drawings*, then the automatic writing drawings, followed by the Cleopatra contract drawings, the black drawings, and the silk drawings, leading finally to the *Monument Drawings*.

Monuments and Steles

From the paper "monuments" to the fifteen-foot-high *Africa Rising* (fig. 8) is a huge step. *Africa Rising* was a public monument commissioned by the U.S. General Services Administration and installed in the lobby of the Ted Weiss Federal Building at 290 Broadway in New York to memorialize the African Burial Ground, excavated in 1991, on which the building stands. My models were both narrative and abstract: the

Fig. 5. Alberto Giacometti (Swiss, 1901–1966). *Standing Figure*, 1957–58. Bronze, 10⅞ × 3⅛ × 6¾ inches (27.6 × 7.9 × 17.1 cm). Philadelphia Museum of Art. The Louis E. Stern Collection, 1963-181-85

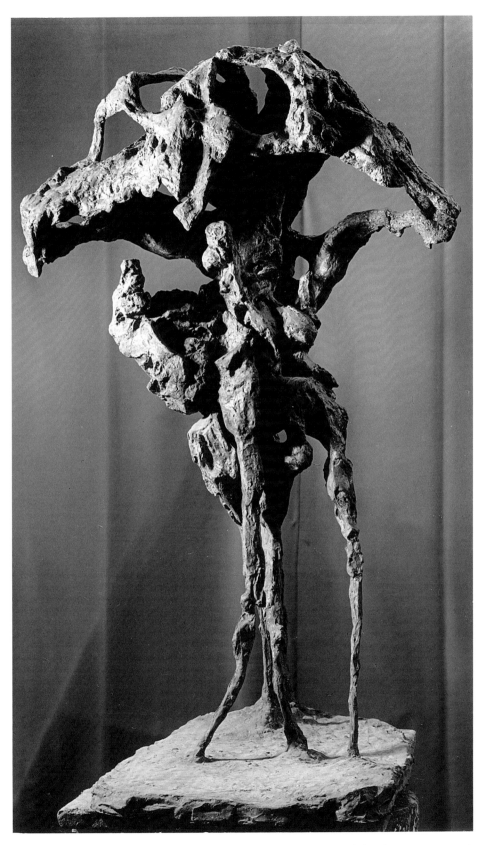

Fig. 6. Barbara Chase-Riboud, *Adam and Eve*, 1958. Bronze, 90½ × 59 × 29½ inches (230 × 150 × 75 cm).
Courtesy of the artist

Nike of Samothrace, Umberto Boccioni's *Unique Forms of Continuity*, and the African headrest often used as a funerary symbol (figs. 9–11).

The African headrest is the most abstract element in this memorial, since I decided to incorporate narrative and recognizable elements as a gesture to its function as a monument conceived for a vast public and utilized specifically as a collective expression rather than an individual one.

The history of funerary steles is a long and complex one. Steles have been a staple of Western and Eastern art for centuries: Egypt, China, Peru, Dogon, Ireland, Scotland, Greece. Thus they have always been a part of human expression, turning up in all civilizations in history and prehistory. Many are merely descriptive writings, others have symbols or sculpture. I chose to memorialize the memorial by putting in the abstracted image of Sarah Baartman, known as the "Hottentot Venus," who became in the nineteenth century the mother of scientific racism and, as a result, a symbol of resistance to racism. This was the result of my own historical novel of the same name that dealt with this subject, as well as my desire to literate this stele rather than leaving it as only pure abstraction.

It was only after I had decided on this formula that the unknown story of Isamu Noguchi's *Memorial to the Dead of Hiroshima* came to light (fig. 12). In 1952, the architect of the Peace Park at Hiroshima, Kenzo Tange, commissioned the sculptor to design a memorial to the dead of Hiroshima, which resulted in one of the greatest memorials of all time never realized. An amorphous black granite form, half arch and half mushroom, of enormous proportions and through which one could pass, it was rejected by the mayor as too abstract, too incomprehensible

Fig. 7. Fra Angelico (Italian, c. 1390/95–1455). *Virgin of Humility*, c. 1436–38. Tempera on panel, 29⅛ × 24 inches (74 × 61 cm). Rijksmuseum, Amsterdam

to ordinary people—plus Noguchi was an American. The world was denied a masterpiece, and for Noguchi it was the tragedy of his life from which he never recovered.

I believe in the power of public sculpture, and the power of memorialization for that purpose. I hope that Noguchi's masterwork will one day be realized in America as well as in Japan, as we still need in 2013 this monument to 221,000 dead, just as we need Maya Lin's Vietnam Veterans Memorial in Washington (see Shaw, fig. 4 above). Maya Lin's wall could easily be seen as a stele turned on its side, slicing the landscape much like Frank Lloyd Wright's unrealized 528-story *Mile High Illinois* skyscraper, which if it had been built would have pierced the stratosphere as in his 1956 drawing (fig. 13).

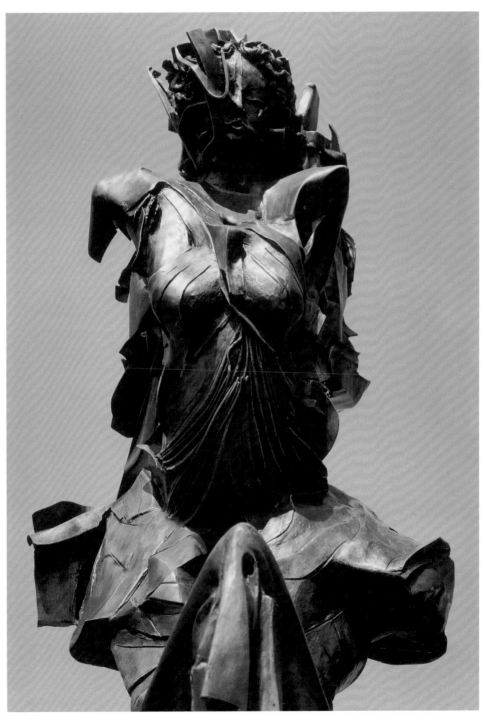

Fig. 8. Barbara Chase-Riboud, *Africa Rising*, 1995–98 (detail). Ted Weiss Federal Building, New York. Commissioned through the Art in Architecture Program, U.S. General Services Administration. Courtesy of the U.S. General Services Administration, Public Buildings Service, Fine Arts Collection

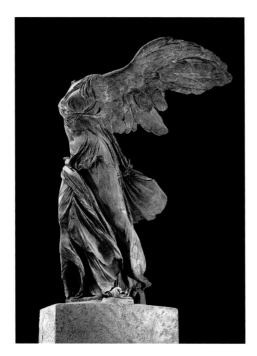

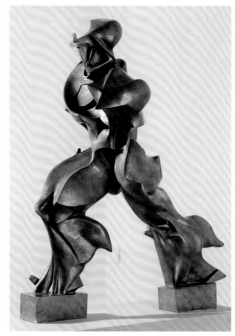

Fig. 9. Nike of Samothrace, c. 190 BCE. Marble, height 129 inches (328 cm). Musée du Louvre, Paris. Digital image © RMN-Grand Palais / Art Resource, NY

Fig. 10. Umberto Boccioni (Italian, 1882–1916). *Unique Forms of Continuity in Space*, 1913. Bronze, 48 × 15½ × 36 inches (121.9 × 39.4 × 91.4 cm). Museo del Novecento, Milan, Italy. Photograph courtesy Scala / Art Resource, NY

I conceived my *Middle Passage Monument* (fig. 14) in 1991 and wrote its manifesto. Since that time I have published it, gone to Washington, to Congress, to the Black Caucus, to the African Summit, even sent it again for the last time to President Clinton when he was signing his National Park proclamations at the end of his second term. But despite blood, sweat, and tears, this proposal fell on many deaf ears. This is the mother of all my steles, which consists of two thirty-six-foot-high pylons with a bridge suspended between them wrapped with a chain representing the eleven million deported Africans who died in the Middle Passage. The manifesto consists of a plea for a proclamation of

apology by the President in the name of the American people for enslaving the ancestors of their co-citizens. Like Noguchi's *Memorial to the Dead*, it remains unrealized.

The *Monument Drawings*

For many years I kept a great divide between my writing and my graphic work and sculpture as I felt it was very dangerous to confuse, merge, or combine two professions and expect to be taken seriously. It was Anthony F. Janson, author of *Janson's History of Art*, who insisted that there was, had to be, a profound connection between the drawings and the poetry. He decided to

Fig. 11. Headrest, Shona peoples, Zimbabwe, nineteenth to twentieth century. Wood, 5⅝ × 6¼ × 2½ inches (14.3 × 15.9 × 6.4 cm). The Metropolitan Museum of Art, New York. Anonymous gift, 1986 (1986.484.1). Image © The Metropolitan Museum of Art. Image source: Art Resource, NY

mount an exhibition in 1998 to prove it, called *Monument Drawings*. Initially, this series had been combined with earlier drawings, but in the end I made twenty-four drawings in charcoal pencil especially for the exhibition. I etched onto the drawing paper an independent element of stone legated by silk cords, which was integrated into each of these drawings and served as a leitmotif. Drawing for me by this time had become the same as and of parallel importance to the writing of poetry, and I had already published two volumes of poems, one of which, *Portrait of a Nude Woman as Cleopatra*, had won the Carl Sandburg Award for best American poet.

In this series of drawings, which begin with an engraved element that remains the same in every drawing, gathering them together under one dark and mysterious banner, the stone cord object that hovers or is buried within the draw-

Fig. 12. Isamu Noguchi (American, 1904–1988). Model for *Memorial to the Dead of Hiroshima* (unrealized), 1952–82. Brazilian granite, stainless steel, wood; 31½ × 59 × 19½ inches (80 × 149.9 × 49.5 cm). Courtesy of The Isamu Noguchi Foundation and Garden Museum, New York

ing becomes the central agent of the ensemble, visible but hidden, active but secret. Is this black stone legated in silk related to the person whose monument this is, or is it completely alien, from another country, another epoch?

Despite my acceptance in the literary world and academia, I still feel a certain distance should be kept from my visual work. Am I a sculptor who writes or a writer who sculpts, and which is my *Ingres's Violin*? For me, neither. I adhere to the same professional standards and criteria in the closed worlds of both disciplines, much to the annoyance of more than a few. However, at this late date, there is nothing to be done about it. When I have exhibited I have also published, and where I have published I have also exhibited.

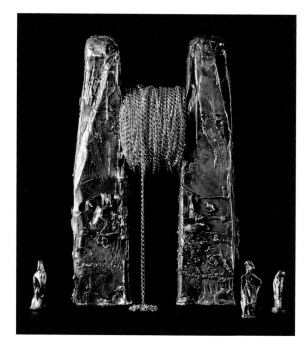

Fig. 13. Frank Lloyd Wright (American, 1867–1959). Perspective drawing for *The Mile High Illinois* (unrealized), 1956. Pencil, color pencil, ink, and gold ink on tracing paper; 96 × 23⅜ inches (243.8 × 59.4 cm). The Frank Lloyd Wright Foundation

Fig. 14. Scale model #2 for Barbara Chase-Riboud's *Middle Passage Monument* (unrealized), 2006. Bronze, height 12³/₁₆ inches (31 cm). Courtesy of the artist

One might say that my real sculpture, like my writing, is the archaeological excavation of history in the form, not of artifacts, but of imaginary reincarnations both as sculpture and as literature. Indifferently.

I recall an article I wrote for *Le Monde*, the *New York Times* of France, called "The Pleasure of Being Foreign," in which I quoted Philadelphia's Man Ray, the American Surrealist and Dadaist artist who, if anyone asked him why he lived in Paris, always replied in his best American-accented French, "J'aime être un étranger!" which translates, "I love being a foreigner!" A typical comment for a Surrealist! Man Ray, who died in 1976, was the mentor and surrogate father of my husband, who published many of the multiples Man Ray produced in the late 1960s and 1970s, such as *La Boîte de Pandora* and *La Fortuna III*. Man Ray lived right down the street from me, facing the Luxembourg Gardens, until he died—as he wished, in Paris, a foreigner and a Philadelphian to the end. The moral of this story being never underestimate which "foreigner" you may run into in Paris. I found in my papers this citation from Juliet Man Ray, his widow, dated 1988, in which she says that on the tenth anniversary of Man Ray's death in November 1986, she had a memorial erected in the Montparnasse cemetery where he is buried, on which is written "unconcerned but not indifferent," his favorite saying and, I must say, mine. And perfect for any poet.

———

I'd like to thank the Philadelphia Museum of Art; its director, Timothy Rub; my curator, Carlos Basualdo, and his assistant, John Vick; the staff of the museum; the public for taking the time

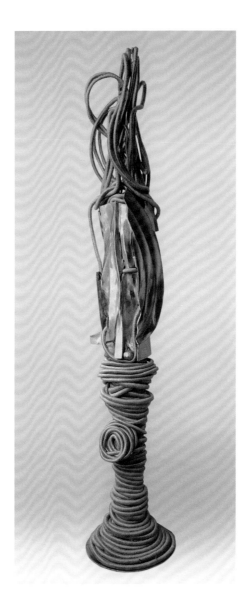

Fig. 15. Barbara Chase-Riboud, *Anne d'H*, 2008. Bronze and silk, height 82⅝ inches (210 cm). Philadelphia Museum of Art. Promised gift of the artist in memory of Anne d'Harnoncourt

to hear me; and my sons and my better half, who have survived the preparation of this exhibition with I hope only superficial wounds. Good night and may you live in interesting times.

In the Silk-and-Bone Shop of the Heart

A Meditation on the Art of Barbara Chase-Riboud

Ellen Handler Spitz

> Memory fills my body as much as blood and bones.
>
> — Colm Tóibín[1]

> Every art form fights the noose of verbal description.
>
> — Alex Ross[2]

Barbara Chase-Riboud, throughout related series of vigorous two- and three-dimensional works, engages viewers in a passionate project that explodes conventional binary categories and their concomitant hierarchical implications: black/white; male/female; soft/hard; 2-D/3-D; static/dynamic; secret/revealed—dichotomies engraved from childhood into the soft tissue of our brains.[3] Confronting her magnetic art, we must respond; and, as we do, her work seems to rise, that being an expression dearly treasured by the artist.[4] The longer we gaze, the more her art draws us into its vortex, past our initial gasps, and releases its inexhaustible cornucopias of innuendo. Yet, our gasps never quite cease! Her works retain their awe, a feature that alone assures their enduring worth.

A recent Philadelphia Museum of Art catalogue, *Dancing around the Bride: Cage, Cunningham, Johns, Rauschenberg, and Duchamp*,[5] explores affinities between sculpture and dance through works by these artists. As I ponder Chase-Riboud's oeuvre, *New Yorker* dance critic Joan Acocella serendipitously brings these realms together for me with her elegant turn of phrase "an ambiguity that feels like clarity."[6] She intends these words as a *bon mot* to describe the innovative choreography of Mark Morris, but they trenchantly capture the spirit of Chase-Riboud's mesmerizing graphic and plastic art.

With unabashed admiration, I dedicate this brief essay to fragments of Chase-Riboud's sustained and sensuous corpus, where touch, memory, and desire (as T. S. Eliot would have it)[7] tangle with contemplation, where that which is private reverberates across time and space with that which is public. Chase-Riboud's art eludes the beholder while inveigling her. It whispers, rarely shouts. It compels attention by giving voice to an ever-renewing engagement with what is authentically human. To encounter her art is to open one's pores to an influx of uncanny sensation and to emerge bewitched, serenely altered. Pores matter to an art profoundly concerned with skin and bone and bodily presence.

Prodigiously gifted and almost unimaginably protean, Chase-Riboud has long functioned alternatively and simultaneously as sculptor, draftsman, poet, and historical novelist, and she merits widespread recognition throughout her native land. Such preeminence, while achieved abroad, has yet to be accorded her fully in the United States, a fact that may be attributed to the circumstance that, after her early childhood years in Philadelphia, she spent her entire adult life in Europe, where she has divided her time between Paris and Rome. Her abiding sense of herself not only as a cosmopolite but as an American may be likened to that of sister artist Gertrude Stein, whose literary oeuvre, in its deceptive naïveté, engaged reverberation, and echolalia, bears an affinity to Chase-Riboud's visual art, and who, similarly residing abroad, famously declared herself an American whose hometown was Paris. Another artist who comes to mind is fellow sculptor Louise Bourgeois, supreme inventor of provocatively signifying bodies and installations (fig. 1), whose Paris–to–New York trajectory reverses Chase-Riboud's transatlantic direction. Chase-Riboud shares Bourgeois's fascination with knotting, wringing, and twisting, and both great women artists exude the sensuality from which all deep art must come: First, says Freud, comes the body.[8]

The artist's early years in Philadelphia cast a poignant glow over Chase-Riboud's 2013 exhibition of sculptures and drawings at the Philadelphia Museum of Art, a show that constitutes a veritable homecoming. Her life and remarkable literary achievements have been chronicled and much celebrated elsewhere.[9] Here, I limit myself

Fig. 1. Louise Bourgeois (American, born France, 1911–2010). *Maman*, 1999. Bronze, stainless steel, and marble; 365 x 351 x 403 inches (927.1 x 891.5 x 1023.6 cm). Installed in the Jardin des Tuileries, Paris, in 2008. Photograph by Georges Meguerditchian, © Louise Bourgeois Trust / Licensed by VAGA, NY

to meditating on her mysterious, compelling *Monument Drawings* and her steles of bronze and silk. My essay draws on perceptive, indispensable discussions by Peter Selz and Anthony F. Janson.[10] I cede obvious issues of race, feminism, and politics to other authors so as to offer in these pages an idiosyncratic contemplation of selected aesthetic elements of Chase-Riboud's art.

In my own life, Barbara Chase-Riboud appeared unforeseen, materializing like one of occultist Madame Blavatsky's aloof and elusive shades. Picture a late afternoon in mid-June, about a year ago, the time of day when shadows lengthen. Suddenly, a stately, dark figure, graceful and armed with what I soon recognized as her understated, ever-present, knowing, and enigmatic half-smile, appears at my side. I had not seen her approach. We converged on a pathway at Flavigny-sur-Ozerain, a storied medieval village in the Côte d'Or, an erstwhile pilgrimage site en route to Santiago da Compostela—a place of dusky catacombs, massive carved portals, a thriving Benedictine abbey, and multiple stone dwellings. Tenderly kept gardens, sprawling yet compact, give out over the terrain where, in 52 BCE, a band of rudely caparisoned Gauls, under their doughty chieftain Vercingetorix, did battle with Julius Caesar and

his armored, invading Romans. Not coincidental but fateful—as I later learned and mused upon—to be encountering this protean artist in a place of historic significance.

Strangers, Barbara Chase-Riboud and I trod the Burgundian village pathways that day in the company of several others; we eyed one another curiously—or perhaps it was only I who felt curious. We had been guests at a celebration with strawberries and champagne hosted by a mutual American friend, the writer Florence Ladd. A day later, seated side by side, we returned to Paris by TGV. In this manner, ripe with personal and cultural import, I encountered the Delphic artist and learned firsthand of her life's work.

Skin, Stone, Serpent, String: Approaching the *Monument Drawings*

Imagined worlds . . . lodge deeply in the private sphere, dislodging much else, especially when the public sphere is fragile.

— Colm Tóibín[11]

Chase-Riboud's *Monument Drawings* series consists of twenty-five works on paper, all identical in size—about 31½ by 23½ inches—started

in the 1990s, and they brook no compromise. Mesmerizing acts of drawing with fine charcoal pencil and pen and ink over an elusive but omnipresent etched core—a reiterated ossific bar—on soft-wove Arches paper, these are works that command homage. Homage especially today, in our twenty-first century, when artists are defecting en masse from the delicacy and refinement of traditional media to the electrified screen, with its primitive hand-eye functions of tapping and sliding.[12]

Classically trained from her earliest years at the Tyler School of Art in Philadelphia, Chase-Riboud knows drawing as *the* core practice in visual arts: through drawing, one stretches, rises *en pointe*, reaches like a dancer, and then loops back to ground. Her lines, moreover, suggest a weaver's warp and woof—not to mention that, made by a sculptor, her *Monument Drawings* hum with volume as well as line. Were we to liken them to music, we should find them richly polyphonic. They ring out with the sensuality of touch, the confidence of the searching hand, and they never shy from erasures, imperfections, or second thoughts—all present to remind us of their, and our, humanity. Smudges and traces of Chase-Riboud's drawing fingers invite us to marvel at and participate in their execution.[13] "Watching" or "listening to" them, even more than "beholding" them, we intuit alterations in the pace that brought them into being. We relive the hypnotic hours spent, as if with piano keys or weaving threads, and imagine the artist entranced, moving her hand back and forth over the page as over her keyboard or loom. As in the music of Philip Glass, we discover subtle, often almost imperceptible, variations. The art of Chase-Riboud thrives in recurrence, never in repetition.

Surely these large works on paper suggest an arcane visual autobiography in that their titles inscribe a wild variety of associations with—we may assume—both historical and geographic significance for Chase-Riboud,[14] including references to writers, artists, monarchs, and prelates, and to both resistors and oppressors. Yet, beyond verbal reference, her haunting images are largely nonrepresentational. In the category of oppressors, for example, consider *Hadrian's Monument, Rome*, of 1996 (see plate 31), in which a central horizontal band below a snake-like form reveals a purposely undecipherable text block replete with tiny pyramids, asterisks, squares, arrows, and stylized eyes, as if borrowed from ancient Egyptian hieroglyphs, all surmounted by a miniature architectural rendering at top that excludes any curved lines. Below, superimposed on the etched rope-and-bone that appears on every sheet in the series, we can imagine a wide staircase leading to an open arch behind which is light. Nonplussed by the image, I gradually recall that it was Hadrian, imperator of Rome, under whose rule harsh anti-Jewish laws were enacted and under whom, according to Dio Cassius, 580,000 Jews were slaughtered during the Bar Kokhba rebellion. Instantly, my association darkens the mood of the drawing.

By way of contrast, at least for me, Chase-Riboud offers a "monument" to Émile Zola (*Zola's Monument, Paris*, 1997; see plate 33), whose ringing "J'accuse" of January 13, 1898, denounced the rabid anti-Semitism of his native France during the infamous Dreyfus affair. Zola's "monument," like Hadrian's, includes a miniature architectural rendering, but the rest of the page, with its oddly irregular segmented forms that resemble slate tiles joined by mortar, and into which a central aperture opens out onto a

Fig. 2. Barbara Chase-Riboud, *Chevalier de Saint-George Monument, Paris*, 1996 (detail of plate 25)

lonely de Chirico–like forest of columns, varies incomprehensibly from the one to Hadrian. Perplexity ensues.

Thus, each drawing in the *Monument* series, by title, internal inscription, or both, refers to a personage or space locatable in historic time with global, or occasionally fictional, coordinates. Literary notables such as the Marquis de Sade, Alexander Pushkin, and Oscar Wilde are readily identifiable, while others prove considerably more obscure, such as Quattrocento architect, painter, and sculptor Francesco di Giorgio (*Monument Francesco di Giorgio, Florence*, 1997; see plate 35), who, like Chase-Riboud, was a gifted polymath, or the Chevalier de Saint-George (*Chevalier de Saint-George Monument, Paris,* 1996; fig. 2), an eighteenth-century French duelist, equestrian, and composer from the Caribbean island of Guadeloupe, the so-called black Mozart, in whose "monument" a loosely roped phallic pinnacle is strangely hemmed in by horizontals and verticals that ambiguously control it.

Fictional characters are memorialized too. Lady Macbeth, for example (*Lady Macbeth's*

Monument, London, 1996),[15] is imagined as a guilt-ridden suicide, perhaps, whose spotted, segmented right hand sprouts tassels of cut rope and depends from above, where a profusion of nooses abounds. *Count of Monte Cristo Monument, Monte Cristo*, of 1996 (see plate 29), resembles twin craggy pinnacles that rise aloft from thread and bone, evocative of a key episode in the novel when the ill-fated Edmond Dantès, after Abbé Faria dies, simulates his friend's corpse and, trussed up inside the latter's body bag, plummets—after being dropped by prison guards—from the ramparts of the Château d'If into the sea.

Chase-Riboud also includes deliberate oddities: *Alfred* rather than Robert Musil, the author of *The Man without Qualities* (1930–42); a different Hatshepsut from the renowned ancient Egyptian pharaoh and patroness of the eighteenth-dynasty architectural wonders at Deir el-Bahri (see plate 40); Peter Paul Rubens's *mother*, rather than the artist himself (see plate 24); and *Cardinal* Ricci, rather than the remarkable Jesuit scholar and traveler Matteo Ricci.[16]

Cardinal Ricci Monument, Palazzo Ricci, Rome, of 1996 (see plate 26) curiously contains a solid yet spongy mass held together with ropes that cannot be distinguished either as helpful cords (like the wrappings of a secure package) or as chains that imprison its bulbous form. Such titular and imagistic bedeviling induces a mild form of cognitive dissonance and thrusts Chase-Riboud's work toward us defiantly, like a pitch we may choose to swing at or refuse: What to make of such incongruously dedicated "monuments" with their tenuous ties not only to one another, but also to themselves and to our expectations?

Art critic and philosopher Arthur Danto suspends his habitual irony for a moment, while writing on Pieter Bruegel's exquisitely arch *Landscape with the Fall of Icarus*, when he remarks: "A title . . . is more than a name or a label; it is a *direction* for interpretation."[17] But this might prove facile apropos Chase-Riboud, for, as I see them, her titles engage in a form of contrarian practice. One recalls René Magritte, whose uncanny images acquired their monikers de post facto, when the eccentric Surrealist painter jested wryly with cronies during habitual afternoon *séances* in a favorite Brussels café.[18] Might the titles of the *Monument Drawings* be read not as an invitation to decipher and unravel them (despite their tangled strings) but as a refusal of constriction: a rebellion against typical one-to-one concordance of title-cum-work—a gesture, in other words, that rhymes with Chase-Riboud's quest to demolish the rigid categories that bind thought? She draws, after all, so many ropes! Pari passu, she unties our mental knots as we contemplate her art. She invites us to invent our own associations (as I have done) and even, if we wish, to bypass her titles altogether. In any case, to presume to probe *her* psyche would be unseemly, as she indicates

in her *Monument to Oscar Wilde*, of 2011 (see plate 42), where she quotes playfully from the preface to *The Picture of Dorian Gray*: "To reveal art and conceal the artist is art's aim."[19]

Equivocation and secrecy seem core to her project. Staring at the *Monument Drawings*, with their looped, rumpled, twisted, wrinkled, enfolded, and stretched lines, I am moved to wonder how drawing has changed (or not) in purpose, method, and cultural status since its earliest known forms at, say, Lascaux and Altamira.[20] This prehistoric practice, rediscoverable in Barbara Chase-Riboud's art, becomes now a co-creation of participating selves through fantasy and memory. Her abstract forms work projectively. Reiterated lines of pen and charcoal over the identical but disguised etched core on sumptuous surfaces—which beg to be caressed—elicit recollection and association. They do so, moreover, in a manner reminiscent of the way the artist herself appeared initially to me—that is to say, they materialize and imperiously attract both curiosity and undivided attention. To experiment with my hypothesis regarding secrecy, I gave a six-year-old boy who loves to draw a set of reproductions of Chase-Riboud's *Monument Drawings* and assigned him the task of finding the etched image in each of them. After slow, passionately engaged examination, he caught on and succeeded, but he told me gravely midstream that on some pages the etched form was "hiding!" This seems a splendid reading of Chase-Riboud and one that matches Acocella's epigram about ambiguity and clarity.

Spellbound by the complexities of *Queen Sheba's Monument, Addis Ababa*, of 1997 (fig. 3), with its maplike form, fluted swirls (as if from the volutes of an Ionic capital),

Fig. 3. Barbara Chase-Riboud, *Queen Sheba's Monument, Addis Ababa*, 1997 (detail of plate 36)

and strewn and scattered stone pieces with their shadows and striations in delicate ink, I am struck by an etymological aperçu: The Latin terms for drawing, *depingere* and *describere*, as well as *disegnare* (Italian), *zeichnen* (German), and *dessiner* (French), all denote mark-making but also, despite varying degrees of nuance, connote projects of self-construction. What does it mean—as Chase-Riboud does—to pull form from blankness, to coax it by means of inert

tools? She both imposes and destabilizes order. To draw is to defy as well as to exploit the limitations and potentialities of given material. To cajole form into being by means of line and shadow is to engage, moreover, with choice and therefore with exclusion and loss. Elegiac as well as ironic in mood, Chase-Riboud's art prompts a level of anguish, for within each of her "monuments," we sense not only a rising rush of power and elation but also the deprivation necessarily implied by choice: a tail unfurls; a rope uncoils and coils again; something is recondite; whatever is revealed remains concealed. Strings spell limits, signaling a "no" or sometimes a "yes"; they ask to be read as *definition*, emphasis, strong noticing. To bind or wrap is to constrain, but also to care, protect, and save.

Chase-Riboud's drawings save by externalizing what is within—within, that is, both herself and us—just as do, for example, the haunting pen-and-ink drawings of German artist Unica Zürn, whose arabesques and curvilinear intricacies, while aesthetically alien to the horizontals and verticals of Chase-Riboud, relate in this special sense (fig. 4).[21] To behold these artists' graphic products is to face inner and outer experience riddled with porousness; superficially controlled, the images murmur incessantly of what has escaped mastery. Chase-Riboud's art, in particular, hypnotizes us with cords we never knew existed. Unmindfully relinquishing control as we look, we enter a liminal space (rather like E. T. A. Hoffmann's charmed garden of Archivarius Lindhorst)[22] where metamorphic shapes cavort, a master draftsman winds up or unfurls her ropes, and skin suddenly passes into stone and hemp into serpent; sinuous tails emerge from twine as ropes quicken. We hear a hiss and fancy Cadmus, perhaps, slithering away in anguish from

Fig. 4. Unica Zürn (German, 1916–1970). *Untitled*, 1966. Ink on paper, 9⅞ × 7½ inches (25.1 × 19.1 cm). Courtesy Ubu Gallery, New York, and Galerie Berinson, Berlin, © Brinkmann und Bose Verlag, Berlin

ture satisfaction and false closure. Seductively, they woo us away from the frail touch of ghosts. As Freud suggests, monuments often propose manic solutions in order to rescue us from the enduring pain of loss.[25] Chase-Riboud, however, refuses anodynes. Her *Monument Drawings*, to the contrary, implant within us, as I have endeavored to show, a fitful sense of ambiguity and anomie. She refuses to let us off the hook. A monument, she knows, will die with whatever it memorializes unless it can make us think and feel in its presence. Only then can it perform its function. With this thought in mind, let us turn to her sculpture.

Semblances of Selves: Meeting the *Malcolm X* Steles

An involuntary sound escapes my lips as I pass into a spacious, book-lined Tribeca loft where two of Chase-Riboud's sculptures are temporarily housed. I am met by *All That Rises Must Converge / Red*, of 2008 (see plate 8), a work of art that silently commands me at once to change my relative pronoun from the inanimate "that" to the human "who." Seven feet tall, topped by corrugated, bent metal burnished to resemble wood, this apparition seems to rest on a skirt that falls in skeins like rivers of blood that have coagulated and are cascading to the floor all knotted, tangled, braided, and looped. But how can what is heavy lean on what is light and soft? I see a queen and feel no absence of head or arms in her presence. She is complete, majestic, just as she appears before me. What a contrast she offers to the Venus de Milo (figs. 5, 6), who by comparison pales into a species of frail victimhood, damaged and pitiable. Lit from above, with a whorled red skein

his tragic city of Thebes.[23] Boundaries between organic and inorganic melt, ecstatically, away.

It remains merely to question the notion of "monument," a topic much debated in our time. What do we do with the past—both our own and that of the world around us? Monuments are intended to hoist the dead weight of cultural mythology and history, but in so doing they often subvert their mission by relieving us of the charge to remember.[24] Undercutting their own apparent aim, they sometimes stop us from stumbling and trying, however incoherently, to make sense. With their aesthetic answers, monuments prove facile substitutes, taking on the guise of cultural fetishes, offering us prema-

of yarn just below where her heart should be, this sculpture welcomes me into her orbit. She dominates the space around her; she forms, in the words of Susanne Langer, "the semblance of a self."[26]

As the acknowledged and irresistible center of her breathable, palpable, inhabitable three-dimensional domain, she reigns triumphant. Yet, not without anguish. She has loved; she has bled. I am magnetized. For a moment, I try to imagine the space without her, as if she were suddenly to vanish. It would contract, drastically. Her presence centers everything nearby, determining the space and expanding it outward from herself, just as each of us does, from infancy onward, starting from within our own body and reaching out.[27] Wordlessly, from her crimson brilliance, she communes with me, giving substance to the way women have always risen and fallen and risen again. Her bronze armor and sanguinary skirts of silk, marine cord, and other fibers stand for the inextricably antithetical but elemental stuff of women's lives. She exudes dignity. Simply to stand by her is to feel hallowed. How hard it is to leave her; how difficult to step back, to look away, to make the effort to go and view another work by Chase-Riboud, which has been placed across the room.

Malcolm X #11 (see plate 9), completed the same year, seems even larger, as I approach it, than *All That Rises Must Converge / Red*. Its burnished bronze upper portion rains down heavily, but with grace, broad and triumphant, over its similar skirt of tassels, knots, and braids. Here, Chase-Riboud has polished her metal to a shimmering golden sheen. Unlike *All That Rises . . . Red*, the silken threads in this work are of gold, so that internal contrast consists of texture and light rather than hue, the result being

Fig. 5. Aphrodite, known as the Venus de Milo, c. 100 BCE. Marble, height 79½ inches (202 cm). Musée du Louvre, Paris. Photograph © RMN-Grand Palais / Art Resource, NY

a more integrated but no less riveting visual experience. No queen greets me here. Nor do I detect a trace of anthropomorphism, but rather a golden forest or possibly a throne, opulent, luxurious, addressing itself more to my eye than to my sense of touch. While I want to make obeisance to it, it fails to pull me in, as did *All That Rises . . . Red*. Its bronze elements (which Chase-Riboud

Fig. 6. Barbara Chase-Riboud, *All That Rises Must Converge / Red* (detail of plate 8)

composes by bending and shaping sheets of wax in her studio before sending them to be cast by artisans at a Milanese foundry) can, in this more remote piece—with its depressions, ridges, and interstices—be likened to the bas-relief of an abstract painting.

Its many surface golds, enhanced by reflections from tiny overhead lights that sparkle like stars, prompt wonder about the allure of gold. Think of Ovid's tragicomic tale of the foolish Phrygian king Midas with his donkey ears,[28] and of the baleful Grimm brothers' story in which a miller's daughter, fallen victim to her father's thoughtless boasting, must spin roomfuls of straw into gold for a greedy king.[29] An anony-

mous dwarf assists her and exacts from her, in recompense, the one price no woman will pay. A long central braid on the piece, moreover, reminds us of Rapunzel, whose flaxen tresses, plaited by a pertinacious witch, hang down, like the one in Chase-Riboud's sculpture (we can easily imagine), from a lofty tower.[30]

Hard and soft, armored as well as fleece-fashioned, visual but storied, *Malcolm X #11* epitomizes much of Chase-Riboud's oeuvre. It brings to mind other works from her thirteen-piece series commemorating by means of forms originating in stone funeral slabs of ancient Greece the charismatic civil rights leader who was assassinated in 1965. It resembles especially *Malcolm X #3*, of 1969 (see plate 2), which is also gold but burnished to a paler, more silvery cast, and, coloristically, *All That Rises Must Converge / Gold*, of 1973 (see plate 4). In these sculptures, Chase-Riboud perhaps reveals one reason for her protean activity, her desire for self-expression in so many forms of art: Her sensibility shifts. Whereas sensations of the uncanny and the surreal permeate her work, and none of it escapes emotional and cognitive complexity, the sculpture differs from her drawing. A rich aesthetic sensuality prevails in the former, whereas the latter foregrounds her irony and love of the arcane.

Her drawing glories in its secrets. For example, *Pushkin Monument, St. Petersburg*, of 1996 (see plate 30), rewards a spate of compulsive staring, for, whereas its etched ink lines read black and velvety, its pen-and-ink lines—alluding, in my mind, to a thickly planted bamboo grove—gradually come to be seen as casting an eerie bluish aura over the space. Delicate, fanciful coils of rope twist themselves into Hogarthian tangles at bottom left, their color subtle and

faint, but as we watch, traces of yellow, blue, and beige slowly emerge from the beautiful paper. Are we simply imagining this? Are those knots coming loose? What about that headless snake slithering across the top of the page, mirroring the horizontal bar below? Only in her drawing can Chase-Riboud do all of this. The burning gold of her sculptures works otherwise, arresting us corporeally. Her drawings are intellectual monuments, probing unlit craters between word and image, fascinating us with what is difficult (as Yeats might have said), except that I want to give his words a passionately positive spin.[31]

It remains now to circle back to that early-mentioned affinity between sculpture and dance and to point out that Barbara Chase-Riboud's embracing work never stands still. It rises. It summons. It winds and unwinds the yarn of our thoughts, percepts, and feelings. When I close my eyes, *All That Rises Must Converge / Red* springs to life before me and dances to the beating of my heart.

NOTES

Acknowledgments: First and foremost, I am indebted to the artist, Barbara Chase-Riboud, sine qua non. At the Philadelphia Museum of Art, I am grateful to Carlos Basualdo, the Keith L. and Katherine Sachs Curator of Contemporary Art; John Vick, Project Curatorial Assistant; Scott Homolka, Associate Conservator of Works of Art on Paper; and Nora Lambert, Dorothy J. del Bueno Curatorial Fellow. I also wish to extend my sincere thanks to Peter J. Williams, Assistant Professor and Video Program Coordinator, Visual Arts Department, Anne Arundel Community College, Arnold, Maryland; Timothy Phin, Assistant Professor of Ancient Studies, University of Maryland, Baltimore County; Elizabeth Holzman; Jerome S. Bruner; Oliver Sacks; Jay Freyman, Professor of Ancient Studies, University of Maryland, Baltimore County; B. E. Noel, Noel Art Liaison, Inc.; and Rivi Handler-Spitz, Assistant Professor of East Asian Studies, Macalester College, St. Paul, Minnesota.

1. Colm Tóibín, *The Testament of Mary* (New York: Scribner, 2012), p. 2.

2. Alex Ross, *Listen to This* (New York: Farrar, Straus and Giroux, 2010), p. xi.

3. The title for this essay is adapted from William Butler Yeats's poem "The Circus Animals' Desertion" (1936–39), published in *Last Poems and Two Plays* (Dublin: Cuala Press, 1939).

4. Chase-Riboud has titled her works thusly: *Africa Rising*, 1998; *All That Rises Must Converge / Gold*, 1973; *All That Rises Must Converge / Black*, 1973–84; *All That Rises Must Converge / Red*, 2008.

5. Carlos Basualdo and Erica F. Battle, eds., *Dancing around the Bride: Cage, Cunningham, Johns, Rauschenberg, and Duchamp*, exh. cat. (Philadelphia: Philadelphia Museum of Art, 2012).

6. Joan Acocella, "Dancing: Doubleheader," *New Yorker*, April 22, 2013, p. 112.

7. See T. S. Eliot, *The Waste Land* (New York: Horace Liveright, 1922).

8. "The ego is first and foremost a bodily ego." Sigmund Freud, "The Ego and the Id" (1923), in *Standard Edition of the Complete Psychological Works of Sigmund Freud*, vol. 19, ed. and trans. James Strachey (London: Hogarth Press, 1961), p. 26.

9. See the Chronology by John Vick in this volume.

10. Peter Selz and Anthony F. Janson, *Barbara Chase-Riboud: Sculptor* (New York: Harry N. Abrams, 1999).

11. Colm Tóibín, "Our Lady of the Fragile Humanity," *New York Times*, April 4, 2013.

12. For the following discussion of drawing with traditional media versus drawing with the computer, I am indebted to Professor Peter J. Williams (personal communication, April 20, 2013). The computer, in terms of drawing, is a weightless void, and, as a "drawing surface," lacks the sense of heft or pressure perceptible in work made by traditional graphic media. Pressure-sensitive "digitizing tablets," widely used now by artists for drawing, are an attempt to mimic the traditional media of charcoal and paper or brush and canvas. A flat plastic board plugs into the computer and constitutes the surface on which one draws with a plastic stylus. No visible mark or trace appears on the plastic surface. Rather, marks are registered on the computer screen. Digitizing tablets register weight and pressure, and sophisticated tablets can even measure the angle at which

the stylus is held. Effects resulting from variable pressure and angle may be changed de post facto, and additional effects, patterns, or images may be "selected" from a library of options. One might compare this to synesthesia, in that an endless array of options is available when "mapping" a computer's response to such "input." Thus, the digitaliz-ing tablet mimics traditional media but apparently expands what is possible. In the final analysis, however, the weight-lessness of electronic media, the disconnect they enforce between human touch and product, and between immedi-ate intuition and response, changes art in ways that seem analogous to the difference between embracing a loved one in the flesh and over the Internet.

13. It is of interest that Chase-Riboud has composed much of her poetry and fiction in longhand, not on a computer. See Selz and Janson, *Barbara Chase-Riboud: Sculptor,* p. 58.

14. For some of these significances, see Anthony F. Janson, "The Monument Drawings," in ibid., p. 104.

15. See *Barbara Chase-Riboud: The Monument Drawings*, exh. cat. (Wilmington, NC: St. John's Museum of Art, 1997), plate 16.

16. Janson, "The Monument Drawings," p. 104.

17. Arthur C. Danto, *The Transfiguration of the Common-place: A Philosophy of Art* (Cambridge, MA: Harvard Univer-sity Press, 1981), p. 119. Since the time of Danto's writing, the painting (now in the Musées Royaux des Beaux-Arts de Belgique, Brussels) has undergone technical analyses that suggest it may be an early copy after a composition by Bruegel. See, e.g., Manfred Sellink, *Bruegel: The Complete Paintings, Drawings and Prints* (New York: Harry N. Abrams, 2007), p. 271.

18. Ellen Handler Spitz, *Museums of the Mind: Magritte's Labyrinth and Other Essays in the Arts* (New Haven: Yale University Press, 1994), p. 45.

19. Oscar Wilde, *The Picture of Dorian Gray* (1891; Lon-don: Penguin, 1985), p. 21.

20. See Whitney Davis, "Replication and Depiction in Paleolithic Art," *Representations*, vol. 19 (Summer 1987), pp. 111–47.

21. See João Ribas, *Unica Zürn: Dark Spring*, exh. cat. (New York: The Drawing Center, 2009).

22. At the end of Hoffmann's enchanting story "Der gold-ene Topf" (The Golden Pot, 1814), the narrator, who is blocked and cannot finish his story, is invited into a garden of magical flowers and talking snakes by one of his own characters, who secretly finishes his story for him while he revels in the garden.

23. See Ovid, *Metamorphoses*, Book IV.

24. See Ellen Handler Spitz, "Loss as Vanished Form," *American Imago*, vol. 62, no. 4 (2006), pp. 419–33.

25. Sigmund Freud, "Five Lectures on Psycho-analysis" (1910), in *Standard Edition of the Complete Psychological Works of Sigmund Freud*, vol. 11, ed. and trans. James Strachey (London: Hogarth Press, 1957), pp. 16–17.

26. Susanne K. Langer, *Feeling and Form: A Theory of Art* (New York: Scribner, 1953), p. 91.

27. Ellen Handler Spitz, "Primary Architecture and Towers of Books: Reflections on Space and Self in Childhood," in *Center 17: Space & Psyche*, ed. Elizabeth Danze and Stephen Sonnenberg (Austin, TX: Center for American Architecture and Design, 2012), pp. 168–81.

28. See Ovid, *Metamorphoses*, Book XI.

29. See the Brothers Grimm, "Rumpelstiltskin," in *Children's and Household Tales*, vol. 1 (1812).

30. See the Brothers Grimm, "Rapunzel," in ibid.

31. William Butler Yeats, "The Fascination of What's Difficult" (1910), in *The Green Helmet and Other Poems* (London: Macmillan, 1912), pp. 20–21.

Illustrated Checklist
of the *Malcolm X* Steles

John Vick

Barbara Chase-Riboud's first sculpture named in honor of the assassinated civil rights leader Malcolm X debuted on April 30, 1969, with the opening of *7 américains de Paris* at the Galerie Air France, New York.[1] Listed in the catalogue as *Monument to Malcolm X*, and known today as *Malcolm X #1*, the work marked a significant stylistic break from anything the artist had previously shown.[2] Neither figurative nor fashioned from found objects and plaster, it betrayed few links to the sculptures presented at her last exhibition, held three years earlier in Paris, or to past influences such as Alberto Giacometti and Germaine Richier.

Instead, *Malcolm X #1*, cast in bronze, and the four aluminum pieces joining it in the Galerie Air France, continued in three dimensions the exploration of abstract forms seen in Chase-Riboud's *Le Lit (The Bed)* drawings of 1966. The innumerable peaks and valleys of rumpled sheets strewn across an unmade bed, rendered there in black charcoal on white paper, were recaptured in the sculptures through an innovative method that maximized the layered, folded, aggregated aesthetic that the artist sought to achieve. Her sculptural process—first tested around 1965, but not fully developed until 1968—involved a number of steps, as she would later describe:

The first step is to make the sheets of wax, which I stack up until I have four, five, or six large sheets. And then I start cutting and working and bending. And I use heat and hot instruments to cut and to weld the pieces together. And in this way I build up slowly, by adding pieces or subtracting them, the basic shape of the sculpture.[3]

Throughout the spring and early summer of 1969, Chase-Riboud employed this process to begin wax models for three new sculptures in the *Malcolm X* series. Once complete, she cast them in bronze at the Fonderia Bonvicini in Verona, using a direct wax technique that allowed for her characteristically deep undercuts but limited production to one unique copy per sculpture.[4] For *Malcolm X #2* and *Malcolm X #3*, the artist also designed steel structures to support the upper bronze portions, which she masked behind intricately wound, braided, and knotted wool and silk threads dyed to match the black and golden patinas. A similar method was applied to the making of *Malcolm X #4*, but with variations that would allow the sculpture to be viewed fully in the round.

Chase-Riboud had always intended to make these three bronzes appear to levitate by severing their visible connection to any traditional kind of base, but it was not until later that summer that she arrived at the means of accomplishing this goal. On July 20, with the sculptures still in progress, she traveled to Algiers for the first Pan-African Cultural Festival. A letter written three days later hints at exciting ideas and the possibility of big developments on the horizon:

I have found an underlying theme for a new series of sculptures which is quite tremendous and is going to make, I think, a lot of controversy, combining what I know of architecture with what I know of design with what I think I know about North Africa and Africa itself. I suppose the revolutionaries have gotten to me but this is truly a "non-political experiment . . ." More later, when I've figured out a few more things.[5]

While it is difficult to measure the exact impact of the Algiers trip on the artist's work, her return to the studio at the end of July coincided with the production of the distinctive wool and silk elements for the remaining *Malcolm X* sculptures. Chase-Riboud had previously experimented with knotted silk in the aluminum sculpture *Sheila*. Arguably, though, it was not until this moment of figuring things out that she began to treat fiber and metal as interdependent materi-

als, thereby revolutionizing the future direction of her work. *Malcolm X #1*, long since finished and shipped away, was thus left the only sculpture in the series made exclusively of bronze.

On February 7, 1970, Chase-Riboud's first solo exhibition in the United States, *Four Monuments to Malcolm X*, opened at the Bertha Schaefer Gallery in New York. The exhibition traveled to the Hayden Gallery at the Massachusetts Institute of Technology, and then, for roughly the next two years, these four sculptures appeared individually in museum and gallery shows nationally and abroad. In 1971, the Newark Museum acquired *Malcolm X #2*, followed later that decade by the sale of *Malcolm X #1* and *Malcolm X #4* to private collections in Germany. *Malcolm X #3*, the largest and eventually most widely exhibited of the series, was purchased in 2001 by the Philadelphia Museum of Art.

In 2003, Chase-Riboud returned to the *Malcolm X* works after more than three decades—a time that saw the completion of eight celebrated books and innumerable drawings and other sculptures, to name only some of her accomplishments. She added four new sculptures to the series that year, working with the Fonderia Artistica Mapelli in Milan, where she had cast *Africa Rising* in 1998 and still maintains connections today. Technically and stylistically, these works are comparable to those made in 1969, with each bearing its own unique formal qualities and expressive characteristics, as has always been true of the series. Five more sculptures followed in 2007–8, including *Malcolm X #10* and *Malcolm X #13*, which stand out for their dynamic use of not just silk and wool fibers but cords and rope of various kinds and in contrasting tones.

With this, Chase-Riboud concluded her landmark *Malcolm X* series, thirteen works that both represent the beginning of her innovative approach to sculpture—its compositional strat-

egies, material aspects, and relationship to history—and number among the last that the artist has created to date.

NOTES

1. On this and other matters concerning exhibition histories and the dating of works, see the Chronology that follows.

2. The formula for titling the *Malcolm X* sculptures has varied considerably over time, possibly more at the hands of dealers, curators, and authors than those of the artist herself. Early examples include: *Monument to Malcolm X* (Galerie Air France, 1969); *Malcolm X, Monument I* (Bertha Schaefer Gallery, 1970); *Monument to Malcolm X, IV* (Betty Parsons Gallery, 1970); and *Monument III* (Whitney Museum of American Art, 1971). Since the mid-1990s, however, the formula has been streamlined to *Malcolm X, No. 3* and, more recently, *Malcolm X #3*—the latter, along with the "stele" designation, being the convention used throughout this catalogue.

3. Chase-Riboud quoted in the documentary *Five*, produced by Milton Meltzer and Alvin Yudkoff (Silvermine Films, 1971).

4. For the direct lost wax method a sculpture is modeled in wax, with wax rods, or sprues, attached to the sculpture surface. The model is then invested in clay and fired to melt away the wax, which drains through the channels left by the wax rods. Molten metal, such as bronze, is then poured into the mold and moves through the sprue channels to fill the cavity. Once cooled, the clay is broken apart to reveal a unique metal sculpture. The cast metal sprues are cut off, and the sculpture can then be finished (polished and/or patinated). Unlike indirect methods, in which an intermediary version of the original wax model is produced, the direct method leaves little room for error and allows for only a single casting of the original.

5. Artist's letter to her mother, July 23, 1969 (misdated June 23), in *Letters to My Mother from an American in Paris: A Memoir*, by Barbara Chase-Riboud (unpublished manuscript). When asked recently to clarify the details of her statement, Chase-Riboud explained that she was writing specifically about the use of fiber in the *Malcolm X* series, as her activity in the studio later that summer would confirm. Chase-Riboud, e-mails to John Vick, December 17–19, 2012.

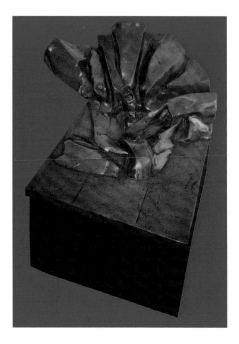

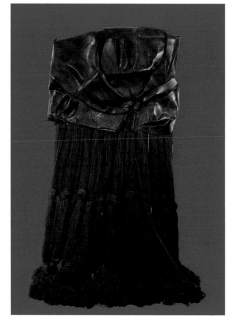

Malcolm X #1
1969
Polished bronze
16 × 29½ × 29½ inches
(40.6 × 74.9 × 74.9 cm)
Private collection, Germany

Malcolm X #2
1969
Black bronze and wool
92 × 42½ × 24 inches
(233.7 × 108 × 61 cm)
Collection of the Newark Museum,
New Jersey. Purchase 1971, Anony-
mous Gift Fund, 71.143
SEE PLATE 1

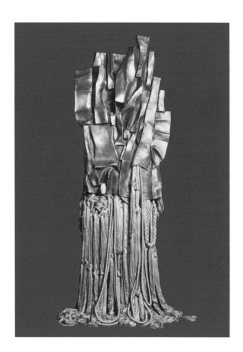

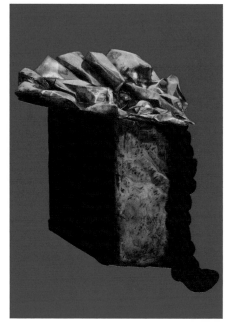

Malcolm X #3
1969
Polished bronze, rayon, and cotton
118 × 47¼ × 9⅞ inches
(299.7 × 120 × 25.1 cm)
Philadelphia Museum of Art. Purchased with
funds contributed by Regina and Ragan A.
Henry, and with funds raised in honor of the
125th Anniversary of the Museum and in cele-
bration of African American art, 2001-92-1
SEE PLATE 2

Malcolm X #4
1969
Polished bronze and wool
47½ × 43¼ × 43¼ inches
(120.7 × 109.9 × 109.9 cm)
Private collection, Germany

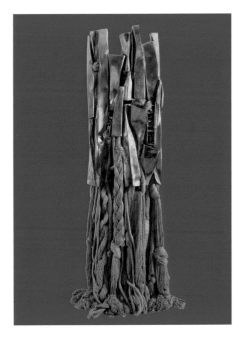

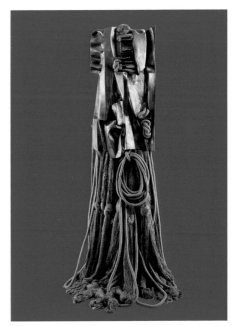

Malcolm X #5
2003
Polished bronze and silk
76½ × 29 × 27 inches
(194.3 × 73.7 × 68.6 cm)
Collection of Nigel, Ayodele, Madison,
and Victoria Hart, New York

Malcolm X #6
2003
Polished bronze and silk
76 × 21⅝ × 15¾ inches
(193 × 54.9 × 40 cm)
Mott-Warsh Collection, Flint, Michigan

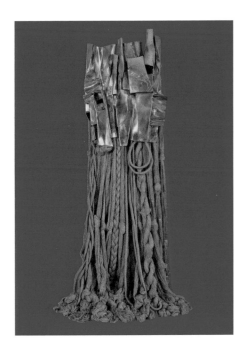

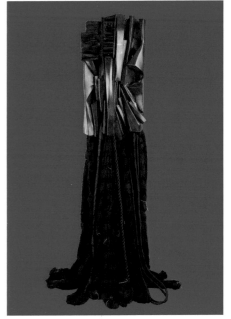

Malcolm X #7
2003
Polished bronze and silk
74 × 40 × 23 inches
(188 × 101.6 × 58.4 cm)
Collection of Roger and
Caroline Ford

Malcolm X #8
2003
Black bronze, silk, and wool
74 × 21⅝ × 15¾ inches
(188 × 54.9 × 40 cm)
Mott-Warsh Collection, Flint, Michigan

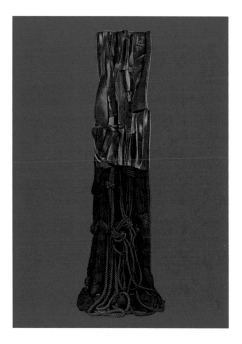

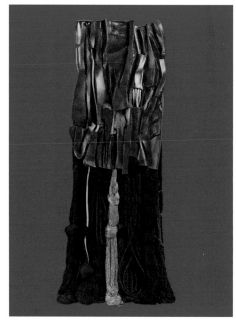

Malcolm X #9
2007–8
Black bronze, silk, and wool
83½ × 27½ × 20½ inches
(212.1 × 69.9 × 52.1 cm)
Courtesy Alberto Rossi, Milan

Malcolm X #10
2007
Black bronze, silk, wool,
and synthetic fibers
78¼ × 34 × 21 inches
(198.8 × 86.4 × 53.3 cm)
Courtesy of the artist
SEE PLATE 6

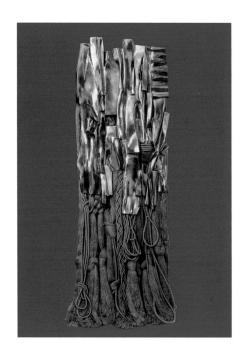

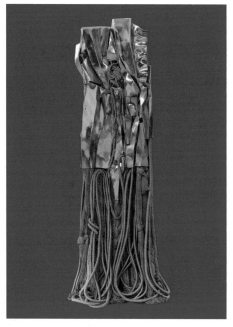

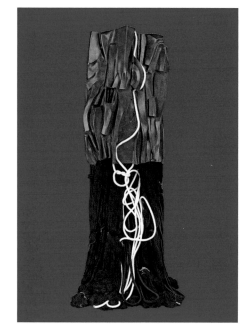

Malcolm X #11
2008
Polished bronze and silk
89¼ × 39 × 29 inches
(226.7 × 99.1 × 73.7 cm)
Courtesy of Noel Art
Liaison, Inc.
SEE PLATE 9

Malcolm X #12
2008
Polished bronze and silk
80½ × 29½ × 21 inches
(204.5 × 74.9 × 53.3 cm)
Courtesy of the artist

Malcolm X #13
2008
Black bronze, silk, wool,
linen, and synthetic fibers
86 × 36 × 25½ inches
(218.4 × 91.4 × 64.8 cm)
Courtesy of the artist
SEE PLATE 10

Chronology

John Vick

1939 June 26: Barbara Dewayne Chase is born in Philadelphia, the only child of Vivian Mae Braithwaite West, a Canadian national from Montreal, and Charles Edward Chase of Philadelphia.[1] Resides with her parents and paternal grandparents, James and Elizabeth Margaret Saunders, in South Philadelphia.

With her mother, early 1940s. Courtesy of the artist

1940s Takes art classes at the Philadelphia Museum of Art and the Samuel S. Fleisher Art Memorial.

Attends Norris S. Barratt Middle School, but is suspended after being falsely accused of plagiarism for her poem "Autumn Leaves." Her mother, who had witnessed the writing of the poem, removes her from school and has her tutored privately at home. It would be decades before the artist would write another poem.

1948 September 8: Is enrolled at the Philadelphia High School for Girls, then located in downtown Philadelphia at Seventeenth and Spring Garden Streets.

1952 June 20: Graduates from high school summa cum laude; her text "Of Understanding" is read at commencement. She is art editor of the school's yearbook.[2]

***Reba*, c. 1954. Woodcut; sheet 23⁷/₁₆ × 17³/₈ inches (59.5 × 44.1 cm). The Museum of Modern Art, New York, SC209.1955. Photograph © The Museum of Modern Art / Licensed by Scala / Art Resource, NY**

Chase-Riboud's paternal grandmother and principal mentor, Elizabeth Margaret (known familiarly as Queen Lizzi), dies. Her parents separate and divorce.

Fall: Begins classes at Temple University's Tyler School of Art in nearby Elkins Park, Pennsylvania, studying with Boris Blai. She is instructed in sculpture, painting, graphic design, printmaking, color theory, and restoration, and in anatomical drawing at the Temple University School of Medicine.

1954 Exhibits prints at the ACA Gallery in New York.

1955 January: The artist's woodcut *Reba* is purchased by curator William Lieberman for the Museum of Modern Art in New York from the exhibition *It's All Yours* at the Carnegie Hall Gallery. The exhibition's sponsor, *Seventeen* magazine, releases its annual "It's All Yours" issue, with Chase-Riboud's print illustrating the short story "Reba."[3]

Spring: Wins a place in the "contemporary graphics" category of a "best of Philadelphia art" exhibition sponsored by Traveling Art, Inc., of Bryn Mawr, Pennsylvania, which tours universities and museums throughout North America and Europe.[4]

1956 Spring: Graduates from Tyler with a bachelor of fine arts degree. Fourteen of her woodcuts are reproduced in the Temple University yearbook, *Templar*, for which she serves as art editor.[5]

Wins a *Mademoiselle* guest-editorship award and moves to New York, taking a job with *Charm* magazine.[6]

1957 The artist's mother becomes a naturalized U.S. citizen.

On the recommendation of art director Leo Lionni, Chase-Riboud wins a John Hay Whitney Foundation fellowship to study at the American Academy in Rome. In late September, the artist leaves New York aboard the French Line ship *Flandre*, en route to Le Havre. She spends approximately one week in Paris before flying to Rome on October 11.[7]

December 31: Departs Italy by ship for Alexandria and a tour of Egypt, where she visits Cairo, Luxor, Karnak, Aswan, and lower Sudan. Chase-Riboud stays with United States attaché Ralph Phillips

With her mother aboard the *Flandre* prior to the artist's departure for Europe in September 1957. Courtesy of the artist

and his wife, Jean, and meets René Burri, a photographer with Magnum Photos.[8]

1958 March 18: Returns to Rome from Egypt, by way of Athens, Delphi, and Istanbul.[9]

In Karnak, Egypt, c. January–March 1958. Photograph © René Burri. Courtesy of the artist

April: A photograph of the artist on the Ponte Sant'Angelo in Rome is published on the cover of *Ebony* magazine; she and more than twenty other African American artists are featured in the issue.[10] Exhibits work in Rome at the American Academy and at Galleria L'Obelisco.

On the cover of *Ebony* magazine, April 1958. Courtesy of Johnson Publishing Company, LLC. All rights reserved

Creates her first bronzes through the direct lost wax method—a technique for producing unique metal castings from wax originals, which the artist will return to nearly a decade later with the production of her abstract sculptures.

June: Chase-Riboud's work is included in the first annual Festival of the Two Worlds in Spoleto, Italy; Ben Shahn purchases her sculpture *Last Supper*. Meets Gian Carlo Menotti, Domenico Gnoli, Mimmo Rotella, and Jerome Robbins.

Summer: Works at the Cinecittà studio in Rome as an extra in a number of films, including *Ben-Hur*.[11]

September: Returns to the United States with a fellowship to begin a graduate program at the Yale University School of Design and Architecture in New Haven, Connecticut. There she meets the artist Sheila Hicks, a fellow graduate student, who will become a close friend, and architect and visiting professor James Stirling. Studies with Josef Albers, Vincent Scully, Alvin Eisenman, Paul Rand, Philip Johnson, and Louis Kahn, among others.

December 5: Her bronze sculpture *Bull-fighter* is included in the *1958 Pittsburgh International Exhibition of Contemporary Painting and Sculpture*, on view through February 8, 1959, at the Carnegie Institute.[12]

1960 Chase-Riboud completes her first public commission, the *Wheaton Plaza Fountain* in Wheaton, Maryland. No longer extant, this pressed-aluminum fountain deployed a vocabulary of abstract shapes repeating across a vertical screen and produced sound and light effects when combined with cascading water. As the fountain was completed without Yale faculty supervision, it did not qualify as a thesis project.

Spring: With a book of engravings illustrating Arthur Rimbaud's *A Season in*

At Yale University, c. 1959. Courtesy of the artist

Wheaton Plaza Fountain, Wheaton, Maryland, 1960 (destroyed). Courtesy of the artist

Hell as her thesis, Chase-Riboud completes her graduate studies at Yale, receiving an MFA.

August: Moves to London to join Stirling, to whom she is now engaged.

Fall: As her marriage plans begin to dissolve Chase-Riboud goes to Paris, where she finds work as art director for the *New York Times International*.[13] Burri introduces her to Marc Eugène Riboud, a fellow Magnum photographer and member of an influential haute bourgeoisie family from Lyon.

1961 After a short courtship, she and Riboud marry on Christmas Day at a church in a hillside village a few miles from Sheila Hicks's ranch in Taxco el Viejo, Mexico. Through the Riboud family,

she meets a number of cultural figures, including artists Henri Cartier-Bresson, Alberto Giacometti, Salvador Dalí, André Breton, Victor Brauner, Max Ernst, and Dorothea Tanning; writers Henry Miller, James Baldwin, and Jean Chalon; and French *Vogue* editor Edmonde Charles-Roux.

1962 Chase-Riboud establishes a studio in Paris at 48, rue Blomet, a street famous in the 1920s for the Bal Nègre, where Josephine Baker performed.[14]

1963 September 22: The artist departs for the Soviet Union, where Riboud is

on assignment to photograph dissident artists, poets, and writers. There she encounters the work of Russian poet Anna Akhmatova and meets the writer Yevgeny Yevtushenko. Returns to Paris in mid-October.

1964 February 23: Her first son, David Charles Riboud, is born.

She and Riboud purchase La Chenillère, a country home in Pontlevoy, in the Loire Valley, France, which they eventually will renovate to include a large sculpture studio. Their neighbors include artist Alexander Calder, photographer William Klein, and Pierre and Nicole Salinger.

With Alexander and Louisa James Calder, Saché, France, 1973. Photograph © Marc Riboud / © Barbara Chase-Riboud

1965 February 21: Malcolm X is assassinated in New York; four days later, Chase-Riboud writes to her mother that she is "very upset over the death."[15]

April: The artist travels to the People's Republic of China to join Riboud, who is there taking photographs; she is the first American citizen invited by the government to visit since the country's political revolution. Attends a state dinner for Mao Zedong with some five thousand guests to celebrate May Day, meeting Zhou Enlai. Chase-Riboud frequents the Forbidden City, where she marvels at waterworn scholars' stones,

Dancing with James Baldwin, Spain, 1962. Photograph © Marc Riboud / © Barbara Chase-Riboud

Visiting Salvador Dalí at his home in Figueres, Spain, 1963. Photograph © Marc Riboud / © Barbara Chase-Riboud

In the Forbidden City, China, May 1965. Photograph © Marc Riboud / © Barbara Chase-Riboud

In Mongolia, May 1965. Photograph © Marc Riboud / © Barbara Chase-Riboud

comparing them to sculptures by Henry Moore. Travels to Shanghai, Guangzhou, Xi'an, the Longmen Grottoes, and Inner Mongolia, and returns to Paris by way of Tibet, India, and Cambodia in early June, bringing with her a collection of seals, jade, drawings, and paintings that she was permitted to export by the Chinese Ministry of Culture.[16]

Chase-Riboud returns to the studio, making new sculptures that will be cast that winter by the Fonderia Bonvicini in Verona.[17] During visits to the Bonvicini foundry around this time she begins to experiment with sculptures modeled in thin sheets of folded wax, laying the groundwork for a focused and more ambitious development of the method some two years later.[18]

1966 Chase-Riboud receives a sculpture commission from fashion designer Pierre Cardin, whom she met in 1960 through the artist Georges Mathieu, creating two

abstract suits of armor for his building on the Champs-Élysées.

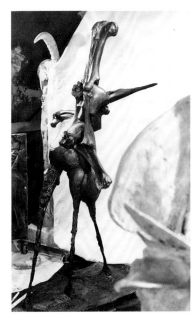

The Couple, 1966. Bronze, approx. 69 × 29½ × 59 inches (175 × 75 × 150 cm). Courtesy of the artist

Late April: The artist represents the United States in Dakar, Senegal, for the first World Festival of Negro Arts, where her sculptures *Figure Volante* and *The Centurion*, both of 1965, are on view in *Ten Negro Artists from the United States*.

November: *Barbara Chase-Riboud: Dessins et sculptures, couples mytholo-giques* opens at the Galerie Cadran Solaire, Paris. Her first major gallery show, it includes sculptures incorporating plaster, bone, and other found objects, some cast in bronze. She also exhibits her drawings from the series *Le Lit (The Bed)* (see plates 11–14), which feature attenuated, faceless figures sprawled across rumpled sheets.

1967 October 21: At the Mobilization to End the War in Vietnam, a major demonstration in Washington, DC, Marc Riboud takes his iconic photograph of a young woman with a flower standing before a line of armed soldiers. Hours later in Paris, on October 22, Chase-Riboud gives birth to her second son, Alexei Karol Riboud. When filmmaker Chris Marker releases his documentary of the protest, *The Sixth Side of the Pentagon* (1968), the opening titles include the dedication "Alexis is born."

1968 Winter/Spring: Chase-Riboud returns to making sculptures, dedicating herself wholly to the modification of large sheets of wax, which she folds, cuts, and fuses to create abstract compositions.[19] Though related in certain formal aspects to the *Le Lit* drawings, these waxes, later cast in bronze or aluminum, mark the beginning of an entirely new sculptural practice.[20]

Meets Niki de Saint Phalle, Jean Tinguely, Françoise Cachin, Roland Penrose, Lee Miller, James Johnson Sweeney, and William and Noma Copley.

Summer: Converts the barn at La Chenillère into a large studio.[21]

November: Sheila Hicks creates a woven tapestry as a gift for Chase-Riboud.[22]

In the studio at La Chenillère, France, c. 1968. Photograph © Marc Riboud / © Barbara Chase-Riboud

At the exhibition *7 américains de Paris*, Galerie Air France, New York, April 1969. Shown (from left): *Sheila*, *Malcolm X #1*, *White Emperor City*, and *Black Light*. Courtesy of the artist

1969 January: Chase-Riboud travels to London to cast sculptures at the Royal College of Art.[23] Later that month, she leaves her Paris studio on the rue Blomet for a larger one on the rue Dutot.[24]

April 30: The exhibition *7 américains de Paris* opens at the Galerie Air France in New York, with Chase-Riboud

represented by five new sculptures, including *Malcolm X #1* (see Checklist, p. 106) and *Sheila*, the latter being the artist's first work to combine cast metal and fiber; Sheila Hicks also exhibits.[25]

Spring/Summer: Gallery owner Bertha Schaefer visits Chase-Riboud at La Chenillère and purchases a sculpture; they also plan the artist's debut solo exhibition in New York the following February.

Chase-Riboud begins waxes for three new sculptures in what will become the *Malcolm X* series (see plates 1, 2 and Checklist, p. 106); by mid-July she writes that she is "working on the last *Malcolm X* (number 4)."[26]

July 20: With her new sculptures not yet complete, she travels to Algiers for the first Pan-African Cultural Festival—a sum-

mit of politics, art, dance, film, music, and theater, held July 21 to August 1, where she meets Angela Davis and Eldridge and Kathleen Cleaver. While there she arrives at "an underlying theme for a new series of sculptures," referring to new approaches for integrating fiber into the three unfinished *Malcolm X* works.[27] Chase-Riboud returns to France—first to Avignon, where her work is on view in the exhibition *L'oeil écoute* at the Palais des Papes, and then to La Chenillère, where she begins

designing the wool and silk elements for her sculptures.

She likely finishes the *Malcolm X* sculptures by year's end, to allow time for their packing and shipping to New York for her upcoming exhibition.

1970 February 7–26: The *Malcolm X* series is shown at the Bertha Schaefer Gallery, New York, alongside thirteen additional bronze and aluminum sculptures and sixteen pieces of jewelry. Hilton Kramer's *New York Times* review of the exhibition and of a concurrent presentation of Romare Bearden's work at Cordier & Ekstrom sparks controversy concerning aesthetics, politics, history, craftsmanship, and expression in the work of African American contemporary artists.[28]

April 10–May 3: Her solo exhibition *Monuments to Malcolm X* is on view at the Hayden Gallery at the Massachusetts Institute of Technology, Cambridge. Chase-Riboud and the *Malcolm X* works are featured on the documentary television program *Like It Is*, produced by WABC-TV, New York.

November: The Betty Parsons Gallery, New York, begins representing Chase-Riboud.[29] The following month, her drawings and sculptures, including *Malcolm X #4*, are shown in a group exhibition at the gallery.

December 12–February 7, 1971: The artist exhibits *The Ultimate Ground* in

Poster designed by Jacqueline S. Casey (American, 1927–1991) for the exhibition *Monuments to Malcolm X*, Massachusetts Institute of Technology, Cambridge, April 10–May 3, 1970. Courtesy of the MIT Museum

the Whitney Museum of American Art's annual exhibition *Contemporary American Sculpture*. Her inclusion follows major protests by the Ad Hoc Women's Art Committee, among other groups, for equal representation of male and female artists, making Chase-Riboud and Betye Saar the first African American women to show at the museum.[30]

1971 April 6–May 16: *Malcolm X #3* is included in the exhibition *Contemporary Black Artists in America* at the Whitney.[31]

May 13–September 6: The Newark Museum, New Jersey, presents *Malcolm X #2* in the exhibition *Black Artists: Two Generations*. In October the museum acquires the sculpture.

May 24: Death of Bertha Schaefer, the first dealer to represent Chase-Riboud.

June 9: *Five*, a documentary about African American contemporary artists produced by Silvermine Films and financed by Seagram Distillers Company, premieres at the Museum of Modern Art; it features (in order of appearance) Chase-Riboud, Charles White, Betty Blayton, Richard Hunt, and Romare Bearden. The segment on Chase-Riboud begins with installation views of her works in the December 1970 group show at Betty Parsons Gallery, and continues with scenes shot by René Burri in late December 1970 or early January 1971 of the artist in Paris, visiting the Bronzalumax Foundry and working in her studio.[32]

Exhibits in Paris at the twenty-third annual *Salon de la jeune sculpture* at the Musée National d'Art Moderne, and at the twenty-fifth annual *Salon des Réalités Nouvelles* at the Parc Floral.

November 6–December 5: Exhibits in *Jewellery '71: An Exhibition of Contemporary Jewellery* at the Art Gallery of Ontario, Toronto.

1972 March 21–April 18: Chase-Riboud has a solo exhibition at the Betty Parsons Gallery. Meets Kenneth Noland, Robert Rauschenberg, and Friedrich Heckmanns,

curator of drawings at the Kunstmuseum Düsseldorf.

Zanzibar/Gold (1972) appears on the cover of the April issue of *Craft Horizons.*

Filming the documentary *Five* at her studio on rue Dutot, Paris, c. December 1970. Courtesy of the artist

The Museum of Modern Art acquires two untitled drawings (see plates 15, 16). One dates from 1966, the period of the *Le Lit* series; the other, from 1971, represents an invented landscape of piled stones that seep watery skeins of fiber cords. This new imagery, which Chase-Riboud develops in drawings throughout the 1970s, is iconographically similar to her contemporaneous sculptures, yet the artist's approaches to each medium remain separate pursuits.[33]

1973 January 17–February 25: The exhibition *Chase-Riboud*, organized by Peter Selz, is mounted at the University Art Museum, Berkeley, California; the sculpture *Confessions for Myself* (1972; see plate 3) is commissioned for the show and later acquired for the museum's collection. The exhibition will travel to the Detroit Institute of Arts that spring, and to the Indianapolis Museum of Art in the summer.

April 14–May 19: Exhibits contemporary jewelry at the Leslie Rankow Gallery, New York.

April 14–September 9: Exhibits in *Gold* at the Metropolitan Museum of Art, New York, which will travel to the Art Gallery of Ontario, Toronto. The Metropolitan acquires an untitled 1972 drawing by the artist (see plate 17). Meets curator Lowery Stokes Sims.

May 15–June 1: She is included in the group show *Sources of Inspiration* at Betty Parsons.

Creates *Cape*, also known as *Cleopatra's Cape*, an armor-like sculpture composed of numerous bronze tiles interconnected with wire, inspired by the ancient jade burial suits of Prince Liu Sheng and Princess Dou Wan, which were excavated in China in 1968 and later photographed by Marc Riboud. She also creates *Cleopatra's Marriage Contract*, combining sculptural elements, drawings, and handwritten script.[34]

November: Exhibits with Antonio Calderara at the Merian Gallery, Krefeld, Germany, which also presents Chase-Riboud's work at Art Cologne.

November 28–December 21: Exhibits in *Jewelry as Sculpture as Jewelry* at the Institute of Contemporary Art, Boston.

1974 Chase-Riboud's first book of poetry, *From Memphis & Peking*, edited by Toni Morrison, is published by Random House and receives critical acclaim.

She is included in the group exhibitions *FOCUS: Women's Work—American Art in 1974* at the Museum of the Civic Center, Philadelphia, and *Masterworks of the Seventies* at the Albright-Knox Art Gallery, Buffalo.

April 25–June 2: Mounts a solo exhibition at the Musée d'Art Moderne de la Ville de Paris.

Summer: Visits Jacqueline Onassis on the Greek island of Skorpios, where they discuss Chase-Riboud's plans to write the novel *Sally Hemings*.[35]

Fall: Solo exhibitions at the Kunstmuseum Düsseldorf and Staatliche Kunsthalle Baden-Baden. *Malcolm X #1* and *Malcolm X #4* are later acquired by private collectors in Germany. Chase-Riboud lectures at the Aspen Institute in Berlin and visits East Germany.

1975 February: Exhibits at Betty Parsons Gallery. Later that month she leaves for a month-long lecture and solo exhibition tour of Africa organized by the U.S. State Department, with venues in Tunisia, Mali, Sierra Leone, Ghana, and Senegal.[36]

May 1–22: Exhibits in the group show *11 in New York* at the Women's Interart Center, New York.

December: Chase-Riboud's drawings are exhibited at the Tehran Museum of Contemporary Art, Iran.

1976 January–February: Solo exhibition of sculptures and drawings at the Kunstverein Freiburg, Germany.

July–September: Solo exhibition at the Musée Reattu, Arles, France.

Zanzibar/Gold is acquired by the National Collections of France.

The artist creates drawings that employ thread woven through paper (see plates 21, 22).

1977 June–October: Chase-Riboud's drawings are included in *Documenta VI*, Kassel, Germany. She also exhibits in the group shows *The Object as Poet* at the

Renwick Gallery of the National Collection of Fine Arts (now the Smithsonian American Art Museum), Washington, DC, which will travel to the American Craft Museum, New York; *European Drawings*, organized by the Art Gallery of Ontario, Toronto, which will travel to the Art Gallery of New South Wales, Sydney, and the Art Gallery of South Australia, Adelaide; and *Les Mains Regardent* at the Centre Georges Pompidou, Paris.

At Monticello, Charlottesville, Virginia, c. 1978. © Susan Wood

1979 Persuaded by Jacqueline Onassis, who had been working as an acquiring editor at Viking Press, Chase-Riboud publishes the historical novel *Sally Hemings*, which wins the Janet Heidinger Kafka Prize in Fiction by an American Woman. The book becomes an international bestseller, attracts film options, and is eventually translated into ten languages. Though it generates protest among many Jeffersonians, the story is supported two decades later by genealogical DNA testing.

April 12–May 27: Exhibits in the *3rd Biennale of Sydney: European Dialogue*.

Exhibits in New York in *3 Sculptors: Barbara Chase-Riboud, Melvin Edwards & Richard Hunt* at the Bronx

Museum, and in *Another Generation* at the Studio Museum in Harlem.

1980 February 17–April 6: Exhibits in the group show *Afro-American Abstraction* at P.S.1 in Queens, New York, which later travels to the Everson Museum of Art in Syracuse, New York.

April: Two scale models of works from the *Malcolm X* series are included in a group show at the Galerie Le Miroir d'Encre, Brussels.

Divorces Marc Riboud.

1981 January 30: *Forever Free: Art by African-American Women, 1862–1980* opens at Illinois State University's Center for the Visual Arts Gallery, Normal. The exhibition, which includes Chase-Riboud's *Confessions for Myself*, will travel to the Joslyn Art Museum, Omaha; the Montgomery Museum of Fine Arts, Alabama; the Gibbes Art Gallery, Charleston, South Carolina; the University of Maryland Art Gallery, College Park; and the Indianapolis Museum of Art.

In New York Chase-Riboud renews her acquaintance with Sergio Tosi, an Italian art expert and publisher of art catalogues and artists' books and multiples. She exhibits drawings at his Stampatori Gallery in New York. They marry later that year. Back in Paris, she meets artists Pol Bury, Pierre Alechinsky, Jean-Michel Folon, and César, as well as Alexina

Sergio Tosi (left) with Man Ray and Juliet Man Ray, early 1970s. Courtesy of the artist

With Pierre Cardin, c. 1981. © Studio G. Delorme, Paris. Courtesy of the artist

"Teeny" Duchamp and Peter and Jacqueline Matisse.

Receives an honorary Doctorate of Fine Arts from Temple University.

1982 July 23: Death of Betty Parsons. Chase-Riboud is left without major gallery representation.

1983 June 21–August 28: Exhibits in *Nœuds et Ligatures* at the Centre National des Arts Plastiques, Paris.

1984 July 22–January 15, 1985: Exhibits in *East–West: Contemporary American Art* at the California Afro-American Museum, Los Angeles.

Creates the bronze and wood sculpture *Cleopatra's Door*, a theme to which she will return with a series of sculptures in the mid-1990s.

1985 Establishes a studio in the Palazzo Ricci, Rome, where she is neighbors with Cy Twombly.

1986 Publishes *Valide: A Novel of the Harem* with William Morrow, who will release Chase-Riboud's other fiction and poetry of the 1980s.

1988 Publishes the book of poetry *Portrait of a Nude Woman as Cleopatra* and wins the Carl Sandburg Award for best American poet from the International Platform Association. A selection of poems from the book is later set to music by composer Andy Vores and first

performed in 1990 by soprano Dominique Labelle.

1989 Publishes *Echo of Lions: A Novel of the Amistad*.

1990 March 27: Purchases a historic garden belvedere on Capri.

April 2–May 4: Chase-Riboud exhibits at the Pasadena City College in California, coinciding with her participation in the school's fourth annual Artists in Residence program, April 23–27; she donates her sculpture *Isis* (1989) to the school's permanent collection.

Begins the *La Musica* series, which she will develop throughout the next two decades. As part of this series she conceives of a monument to Marian

With Tosi in Capri, 1990. Courtesy of the artist

Anderson in red patinated bronze to be erected on the Benjamin Franklin Parkway in Philadelphia.

1991 May 28: Following an eighteen-month court case, Chase-Riboud wins a copyright infringement counterclaim against a play based on her novel *Sally Hemings*.

August 15: Death of the artist's mother in Chestnut Hill, Philadelphia.

1992 January–February: Exhibits in *Paris Connections* at the Bomani Gallery, San Francisco.

Her sculpture *All That Rises Must Converge / Gold* (1973; see plate 4) is acquired by the Metropolitan Museum of Art, and Chase-Riboud meets the museum's director, Philippe de Montebello, and curator William Lieberman, who had acquired the artist's woodcut *Reba* for the Museum of Modern Art in 1955.

1993 Begins making the "shelf sculptures," which follow *Cleopatra's Marriage Contract* in their combination of sculptural elements, drawing, and writing.

May: Receives honorary Doctorate of Letters from Muhlenberg College, Allentown, Pennsylvania.

1994 April 18–May 20: Solo exhibition at the Galerie Flora, Espace Kiron, Paris.

April 26: Chase-Riboud submits a proposal to the White House for a Middle Passage Monument, which she conceived in 1991, to commemorate the "11 million African victims on the bottom of the Atlantic Ocean who perished there through torture, disease, bestial confinement, inhumane treatment, and suicide, which occurred as a result of their enforced deportation into slavery." The proposal also includes a call for a

proclamation of apology on behalf of the American people to their co-citizens for "the crime of slavery perpetrated upon their ancestors by the United States."[37]

Publishes *Roman Égyptien* (Éditions du Félin), a book of French poetry, and *The President's Daughter* (Crown Publishers), a novel that continues the Sally Hemings story.

Speaks at the William Faulkner Festival at the William Faulkner Foundation, Rennes, France.

Creates *Tantra #1* (see plate 5); three more works in the series will follow in 1997 and 1998.

1995 Produces the lithograph *Akhmatova's Monument* at the Brandywine Workshop, Philadelphia, and is honored with the James Van Der Zee Award, now the Brandywine Lifetime Achievement Award.[38]

July 21–October 31: Exhibits in the Fujisankei Biennale International Exhibition for Contemporary Sculpture at the Hakone Open-Air Museum, Japan.

Wins a commission from the U.S. General Services Administration to create the sculpture *Africa Rising* (see p. 29, fig. 6 above) to commemorate the recently discovered African Burial Ground in Lower Manhattan, a colonial-era cemetery for free and enslaved Africans.

September 15–August 27, 1996: Chase-Riboud is included in *The Listening Sky: Inaugural Exhibition of the Studio Museum in Harlem Sculpture Garden*.

1996 January 18–June 2: Exhibits in *Explorations in the City of Light: African-American Artists in Paris, 1945–1965*, organized by the Studio Museum in Harlem, which will travel to the Chicago Cultural Center; the Modern Art Museum of Fort Worth; the New Orleans Museum of Art; the Milwaukee Art Museum; and the Seattle Art Museum.

The artist begins the *Monument Drawings*—executed in charcoal and ink atop identical etchings—completing twenty-

four such works by the following year (see plates 23–42).[39] The series recalls the imagery of her 1970s drawings, as well as the strategy, established with the *Malcolm X* sculptures, of producing nonrepresentational commemorative works. Each drawing is dedicated to an individual or event and most are given a relevant geographic location, echoing in certain ways the artist's concurrent work on *Africa Rising* as well as her historical novels.

Chase-Riboud is knighted by the French government as Chevalier de l'Ordre des Arts et des Lettres.

March 17–September 29: *Malcolm X #3* is included in *Three Generations of African American Women Sculptors: A Study in Paradox*, at the Afro-American Historical and Cultural Center Museum, Philadelphia (now the African American Museum in Philadelphia); over the next two years the exhibition will travel to the Equitable Gallery, New York; the Museum of African American Life and Culture, Dallas; the California Afro-American Museum, Los Angeles; the Museum of the National Center of Afro-American Artists, Boston; the Telfair Museum of Art, Savannah, Georgia; and the Center for the Study of African American Life and Culture, Smithsonian Institution, Washington, DC.

May 19: Receives an honorary Doctorate of Letters from the University of Connecticut.

Summer: Chase-Riboud is included in *Bearing Witness: Contemporary Works by African American Women Artists*, organized by the Spelman College Museum of Fine Art, Atlanta. Over the next three years the exhibition will travel

Palazzo Ricci, Rome. Photograph by Kevin Kriebel

to the Tuskegee University Art Gallery, Alabama; the Fort Wayne Museum of Art, Indiana; the Minnesota Museum of America Art, Saint Paul; the Museum of African-American Culture, Fort Worth; the Portland Museum of Art, Oregon; and the Museum of Fine Arts, Houston.

December: Files a copyright infringement lawsuit against Steven Spielberg's DreamWorks, claiming that the film *Amistad* is based on her book *Echo of Lions*. The suit is settled out of court the following February.

1998 January: Chase-Riboud exhibits at the Stella Jones Gallery, New Orleans. Her sculpture *Plant Lady* is acquired by the New Orleans Museum of Art.

January 23–April 11: The exhibition *Barbara Chase-Riboud: The Monument Drawings* opens at the St. John's Museum of Art (now the Cameron Art Museum), Wilmington, North Carolina; it will travel to the Metropolitan Museum of Art in 1999, and the following year to the African American Museum in Philadelphia and the Walters Art Gallery, Baltimore, where the artist delivers the Annual Theodore L. Low Lecture.

May–September: Exhibits at Bianca Pilat Contemporary Art, Chicago.

June 6: *Africa Rising*, cast at the Fonderia Artistica Mapelli, Milan, is installed in the lobby of the Ted Weiss Federal Building, adjacent to Foley Square in Lower Manhattan.

1999 Peter Selz and Anthony F. Janson complete the monographic study *Barbara Chase-Riboud: Sculptor*, published by Harry N. Abrams.

2000 May–April: Solo exhibition at Moeller Fine Art, New York.

2001 *Malcolm X #3* is acquired by the Philadelphia Museum of Art and exhibited the following year in *Gifts in Honor of the 125th Anniversary of the Philadelphia Museum of Art*.

April 12–August 26: *Cleopatra's Marriage Contract* is exhibited at the British Museum, London, in *Cleopatra of Egypt: From History to Myth*.

2002 Exhibits at the G. R. N'Namdi Galleries in Detroit and Chicago.

2003 Creates four new sculptures in the *Malcolm X* series (see Checklist, p. 107).

Hottentot Venus, Chase-Riboud's historical novel about Sarah Baartman, is published by Doubleday. The book is nominated for the Hurston-Wright Legacy Award and wins the Black Caucus of the American Library Association Literary Award for Fiction.

2004 March 3–April 17: Solo exhibition of sculpture at the Galleria Giulia, Rome.

2006 Noel Art Liaison, Inc., begins to represent Chase-Riboud. The Mott-Warsh Collection in Flint, Michigan, acquires *Malcolm X #6* and will acquire *Malcolm X #8* the following year.

April 5–July 2: Chase-Riboud's work is included in *Energy/Experimentation: Black Artists and Abstraction, 1964–1980*, at the Studio Museum in Harlem.

June 16–January 7, 2007: Chase-Riboud exhibits in *Legacies: Contemporary Artists Reflect on Slavery* at the New-York Historical Society Museum. The museum will later purchase the artist's *Sojourner Truth Monument Maquette* (1999) and *Scale Model Monument / Andrew Green, Father of Greater New York* (2007).

2007 February 17: Chase-Riboud receives a Women's Caucus for Art Lifetime Achievement Award from the College Art Association in New York.

Receives the Alain Locke International Award from the Detroit Institute of Arts.

April: Returns to China to complete work on a travelogue of her 1965 trip to the country, titled *10,000 Kilometers of Silk*.

The artist begins five new *Malcolm X* steles (see plates 9, 10 and Checklist, p. 108), which she will finish the following year, bringing the total number of works in the series to thirteen. She also creates *Tantra #4, All That Rises Must Converge / Red* and *Anne d'H* (named for Philadelphia Museum of Art director Anne d'Harnoncourt), among other works (see plates 7, 8 and p. 91, fig. 15).

2008 Composer Leslie Savoy Burrs creates a jazz opera based on Chase-Riboud's book of poetry *Portrait of a Nude Woman as Cleopatra*.

Birth of granddaughter Mathilde Rose Riboud. The artist completes the Monticello Doll House in Rome.

May 23–July 31: Exhibits in *[un]common threads* at the Michael Rosenfeld Gallery, New York.

July: Solo exhibition of sculpture at the Galleria Giulia, Rome.

November: The artist begins organizing her collected letters to her mother, which commence at the outset of her first trip to Europe in 1957 and end in 1991 with her mother's death.

2009 Summer: The Johns Hopkins University Press publishes a special issue of *Callaloo* devoted to the artist.

2011 Birth of grandson Jules Dewayne de Bilancourt Riboud.

Completes an English version of *Roman Égyptien* (titled *Egypt's Nights*) and the historical novel *The Great Mrs. Elias*.

2012 January 25–April 29: *Malcolm X #11* (2008) is included in *The Annual: 2012* at the National Academy Museum, New York.

Meets artist Frank Bowling, O.B.E., R.A.

2013 Completes *Helicopter*, a verse novel; *Letters to My Mother from an American in Paris: A Memoir*; *Every Time a Knot Is Undone, a God Is Released: Collected Poems*; and *Pannonica & Thelonious*, a melologue for a screenplay.

May 31: Receives a Tannie Award in the Visual Arts in Paris.

NOTES

1. Although various dates appear in the literature we have maintained the year of birth provided by the artist.

2. See Philadelphia High School for Girls, *Commencement Program*, June 20, 1952; and *The Milestone*, published by the 183rd Class of the Philadelphia High School for Girls, June 1952.

3. "Reba," *Seventeen*, January 1955, p. 77. The same issue features illustrations by Richard Hunt and Jerome Witkin. The woodcut *Reba*, now part of MoMA's Study Collection (SC209.1955), is listed as an anonymous gift. However, William Lieberman, then curator of prints and drawings at the museum, is credited as the original buyer; see Peter Selz and Anthony F. Janson, *Barbara Chase-Riboud: Sculptor* (New York: Harry N. Abrams, 1999), p. 135.

4. "Art Jury Selects Works of Nine Students for Tour," *Philadelphia Evening Bulletin*, June 8, 1955, p. 26.

5. The *Templar* yearbooks of 1953–56 portray Chase-Riboud as an active participant in the school's arts and leadership organizations,

including as vice-president of the Tyler Student Council.

6. Mara R. Witzling, ed., *Voicing Today's Visions: Writings by Contemporary Women Artists* (New York: Universe, 1994), p. 176. The artist recalls working on layouts of shoe illustrations by Andy Warhol while at *Charm*.

7. Artist's letters to her mother, September 27–October 15, 1957, in *Letters to My Mother from an American in Paris: A Memoir*, by Barbara Chase-Riboud. All subsequent references to letters from the artist to her mother are to this unpublished manuscript.

8. Artist's letter to her mother, March 7, 1958.

9. Artist's letters to her mother, March 7–20, 1958.

10. "Leading Young Artists, Attitudes toward Negros in Art Have Changed Radically," *Ebony*, vol. 13, no. 6 (April 1958), pp. 33–38.

11. Artist's letters to her mother, June 9–27, 1958.

12. Linked to the celebration of the city's bicentennial, the 1958 show was the first Pittsburgh International since its inauguration in 1896 to include sculptures. Chase-Riboud's work was installed in a stairwell gallery alongside sculptures by Georges Braque, Alexander Calder, Anthony Caro, Germaine Richier, and William Zorach, among others.

13. She will hold a position with the *New York Times International* until at least May of the following year. See the artist's letters to her mother, November 19, 1960, and May 5, 1961.

14. Artist's letter to her mother, February 15, 1962.

15. Artist's letter to her mother, February 25, 1965.

16. Artist's letters to her mother, May 2–22, 1965.

17. Artist's undated letter to her mother, January 1966: "I also have to go soon to Verona for casting all the things I am about to finish."

18. "It wasn't until 1964 or 5 that I began using thin sheets of folded wax at Bonvicini's but still using plaster casts until after the 66 show." Barbara Chase-Riboud, e-mail to John Vick, November 8, 2012.

19. "I didn't make any real folded wax sculptures until after 67–68." Ibid.

20. While her bronzes were direct-cast as unique sculptures by the Fonderia Bonvicini, Chase-Riboud produced her aluminum works at the Bronzalumax foundry in Paris, using a sand-casting technique that allows each wax model to be reproduced many times over, as exemplified by the artist's modular floor piece *Bathers* (1973).

21. Artist's letters to her mother, June 21 and July 2, 1968.

22. Artist's letter to her mother, November 2, 1968.

23. Chase-Riboud went to the Royal College of Art at the invitation of Professor Margaret Stevens, casting *Zanzibar/Gold*, completed in 1972 and later acquired by the French Ministry of Culture, and two other sculptures now in Brussels. She did not return to this foundry because she felt that the bronzes produced there were too heavy and dark. Barbara Chase-Riboud, e-mail to John Vick, October 6, 2012.

24. Linking the move to her ambition as an artist, Chase-Riboud writes to her mother on January 15, 1969: "And we will sign for the new studio next week. It is really now or never. I am determined to be rich and famous."

25. The aluminum element of *Sheila* is now one of several components that constitute the work *Astrological Fountain: Sagittarius/Kiron* (c. 1994–95; Palladium Collection, Espace Kiron, Paris). Chase-Riboud, e-mail to John Vick, October 17, 2012.

26. Artist's undated letter to her mother, c. July 15–19, 1969.

27. Artist's letter to her mother, July 23, 1969 (misdated June 23).

28. Hilton Kramer, "Black Experience and Modernist Art: Romare Bearden Uses Photos in Collages, Malcolm X Is Subject of Barbara Riboud," *New York Times*, February 14, 1970, p. 23.

29. In a letter of November 2, 1970, Betty Parsons writes to Chase-Riboud: "I am very happy that you will join the gallery. . . . Please confirm this in writing." On November 10, Chase-Riboud tells Whitney Museum of American Art curator Robert M. Doty that she is "now represented by Betty Parsons and not Bertha Shaeffer [*sic*] and will therefore exhibit under her name in the two forthcoming exhibits." See the Betty Parsons Gallery Records and Personal Papers, Archives of American Art, Smithsonian Institution, Washington, DC (hereafter cited as Parsons Gallery Records). Doty's catalogue for the 1970 annual exhibition *Contemporary American Sculpture* lists the artist as being with Schaefer's gallery; however, the Whitney's catalogue for *Contemporary Black Artists in America* the following spring lists the Betty Parsons Gallery as Chase-Riboud's representative.

30. See Grace Glueck, "Women Artists Demonstrate at Whitney," *New York Times*, December 12, 1970, p. 19.

31. Some artists boycotted the exhibition, arguing it was neither organized "with the assistance of black art specialists" nor held "during the most prestigious period of the 1970–71 art season," as had been agreed to. See Grace Glueck, "15 of 75 Black Artists Leave As Whitney Exhibition Opens," *New York Times*, April 6, 1971, p. 50.

32. See correspondence of December 21, 1970, and January 8, 1971, between Chase-Riboud and gallery director Jock Truman, in Parsons Gallery Records.

33. Chase-Riboud has on many occasions spoken of the separate tracks within her artistic and literary practices, stating recently that "sculpture was sculpture, drawing was drawing and poetry was poetry and never the twain shall meet." Chase-Riboud, e-mail to John Vick, November 8, 2012.

34. *Cape* was acquired by the Lannan Foundation in 1975 and given to the Studio Museum in Harlem in 1998. *Cleopatra's Marriage Contract* is in the Palladium Collection, Paris.

35. Artist's letter to her mother, September 17, 1974.

36. A preliminary itinerary of the tour found in the Parsons Gallery Records lists Guinea as a destination in place of Sierra Leone.

37. See the artist's proposal and letter of April 26, 1994, published in Selz and Janson, *Barbara Chase-Riboud: Sculptor*, pp. 128–30.

38. *Akhmatova's Monument* (print 50 of 100) was donated to the Philadelphia Museum of Art in 2009 as part of the Gift of the Brandywine Workshop, Philadelphia, in memory of Anne d'Harnoncourt, and later exhibited in *Full Spectrum: Prints from the Brandywine Workshop*, September 7–November 25, 2012. See Shelley Langdale et al., *Full Spectrum: Prints from the Brandywine Workshop*, exh. cat. (Philadelphia: Philadelphia Museum of Art, 2012), p. 29.

39. In 2011, upon finding an unused etching from the series, Chase-Riboud created *Monument to Oscar Wilde* (see plate 42).

Acknowledgments

This exhibition and publication would not have been possible without the efforts of numerous people, both within and outside of the Museum.

For her energy, spirit, and invaluable assistance with the many demands associated with putting together an exhibition and catalogue, we are extremely grateful to the artist, Barbara Chase-Riboud. We are also deeply indebted to her husband, Sergio Tosi, for his amazing hospitality and careful assistance throughout the process, and to her sons, David Riboud, curator of the Marc Riboud Archives, and Alexei Riboud, photographer, for their help in obtaining and identifying photographs for the Chronology.

The initial impetus for the exhibition came from Regina Henry and her late husband, Ragan A. Henry, who generously funded the purchase of *Malcolm X #3* in 2001. The late Anne d'Harnoncourt enthusiastically embraced the idea of an exhibition based around the *Malcolm X* steles, and Timothy Rub has consistently championed the project since his arrival at the Museum in 2009.

We are grateful to The Andy Warhol Foundation for the Visual Arts for generously supporting the exhibition, and The Andrew W. Mellon Fund for Scholarly Publications at the Philadelphia Museum of Art for making possible this catalogue.

It was always our goal to present the Malcolm X steles in context with other sculptures and drawings to show the depth of Barbara Chase-Riboud's artistic practice. We could not have achieved this without the generosity of our lenders: Roger and Caroline Ford; The Metropolitan Museum of Art, New York; the Mott-Warsh Collection, Flint, Michigan; The Museum of Modern Art, New York; the Newark Museum, Newark, New Jersey; Noel Art Liaison, Inc.; the University of California, Berkeley Art Museum and Pacific Film Archive, our partners for the tour; and, of course, the artist herself.

B. E. Noel of Noel Art Liaison, Inc., deserves special mention for her strength of character and gracious efforts beyond the call of duty. Deep thanks are also due to the staff of the Fonderia Artistica Mapelli, Milan; Alberto Rossi Art Brokers, Milan; and Pepi Marchetti Franchi, director of the Gagosian Gallery, Rome.

We are grateful to Gwendolyn DuBois Shaw, Associate Professor of American Art at the University of Pennsylvania, and Ellen Handler Spitz, the Honors College Professor of Visual Arts at the University of Maryland, Baltimore County, for contributing essays to the catalogue, which owes its handsome design to Steven Schoenfelder.

We are indebted to many colleagues at the Philadelphia Museum of Art who contributed their energy and expertise to the project, beginning with Alice Beamesderfer, Deputy Director for Collections and Programs; Gail Harrity, President and Chief Operating Officer; Joseph Meade, Director of Government and External Affairs; Suzanne F. Wells, Director of Special Exhibitions Planning; Yana Balson, Assistant Director of Exhibition Planning; Cassandra DiCarlo, Special Exhibitions Assistant; Irene Taurins, Director of Registration; and Wynne Kettell, Registrar for Exhibitions.

In the Department of Modern and Contemporary Art, special gratitude is owed, first and foremost, to John Vick, Project Curatorial Assistant, for his dedication and help with all phases of this project, including research, acquiring photographs and permissions, and his excellent written contributions to the catalogue. Thanks are also due to Adelina Vlas, Assistant Curator; Erica Battle, Project Curatorial Assistant; Anna Vallye, Andrew W. Mellon Curatorial Fellow; Ashley McKeown, Department Assistant; Kelly Lehman, Administrative Assistant; Ashley Boulden, Exhibition Assistant; and Alexander Kauffman, Andrew W. Mellon Fellow.

In Facilities and Operations, we are grateful to Jack Schlechter, Director of Installation Design; Jeffrey Sitton, Installation Designer; Andrew Slavinskas, Lighting Designer; Martha Masiello, Manager of Installations; and the staff of Installations and Packing.

In the Publishing Department, we thank Sherry Babbitt, The William T. Ranney Director of Publishing; editors David Updike and Sarah Noreika; and Richard Bonk, Book Production Manager.

For bringing the works to life in the catalogue, we are indebted to photographers Amanda Jaffe, Mauro Magliani, Jason Wierzbicki, and Graydon Wood. Thanks also go to Constance Mensh, Photography Technician, and Conna Clark, Manager of Rights and Reproductions.

In the Development Department, we are grateful to Kelly M. O'Brien, Executive Director of Development; Julie Havel, Deputy Director of Development; Caroline New, Grants Manager; and Tracy Carter, Major Gifts Officer.

For their assistance in identifying the materials and mediums of the works, and overseeing their safekeeping, we thank Sally Malenka, The John and Chara Haas Conservator of Decorative Arts and Sculpture; Sara Reiter, The Penny and Bob Fox Conservator of Costume and Textiles; Nancy Ash, Senior Conservator of Works of Art on Paper; and Scott Homolka, Associate Conservator of Works of Art on Paper.

Colleagues in the Department of Print and Photographs generously shared their time and expertise: Innis Howe Shoemaker, The Audrey and William H. Helfand Senior Curator of Prints, Drawings, and Photographs; Shelley Langdale, Associate Curator of Prints and Drawings; James Wehn, Margaret R. Mainwaring Curatorial Fellow; Nora S. Lambert, Dorothy J. del Bueno Curatorial Fellow; Jane Landis, Coordinator of Collections; Sharon Hildebrand, Head Preparator; and Jude Robison, Preparator.

In the Education Department, thanks go to Marla K. Shoemaker, The Kathleen C. Sherrerd Senior Curator of Education; Elizabeth Milroy, The Zoe and Dean Pappas Curator of Education, Public Programs; Barbara A. Bassett, The Constance Williams Curator of Education, School and Teacher Programs; Rebecca Mitchell, Museum Educator, Coordinator of Teacher Programs; Jenni Drozdek, Museum Educator, Adult Public Programs; and Ann Guidera-Matey, Manager of Volunteer Services.

In Marketing and Communications, we are grateful to Jennifer Francis, Executive Director of Marketing and Communications; Norman Keyes, Director of Communications; Kristina Garcia Wade, Press Officer; Maia Wind, Senior Graphics Editor; Barb Barnett, Graphic Designer; Gretchen Dykstra, Editor; Camille Focarino, Director of Special Events; and Leigh Moser, Assistant Event Planner.

Last but not least, thanks to the entire staff of the Museum Library, especially Evan Towle and Rick Sieber, for their invaluable research assistance.

Carlos Basualdo
The Keith L. and Katherine Sachs Curator of Contemporary Art